IMAGES
of America

GRESHAM

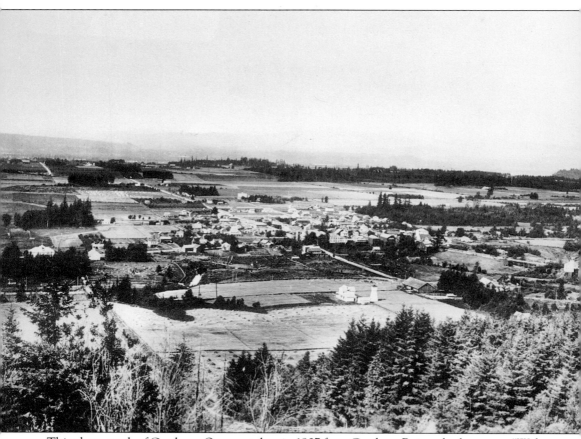

This photograph of Gresham, Oregon, taken in 1907 from Gresham Butte, also known as "Walters Hill" from an early U.S. Army Corps of Engineers designation during World War II, shows many features of the town that are identifiable today. Fairview Avenue is shown coming into town from the north, becoming Main Avenue, which at the time of the photograph extended across Johnson Creek as a walkway or very narrow road. Johnson Creek winds its way into town from the right. Walters Road is shown at the left edge of the photograph, and Powell Boulevard enters town from the left of the photograph. The white house in the lower center is the home of Henry Metzger, an early settler. Mount St. Helens is visible in the upper left. The 1910 census placed Gresham's population at 540.

ON THE COVER: As with almost any town in the early 1900s, Fourth of July parades were well-attended events. Gresham was no exception, as crowds lined the streets for the 1919 parade. Decorated cars and wagons are shown entering from the west, curving around the *Statue of Liberty* at far right, and then heading north along Main Avenue. (Photograph courtesy Oregon Historical Files, NEG. NO. 52325.)

IMAGES
of America

GRESHAM

George R. Miller

ARCADIA
PUBLISHING

Published by Arcadia Publishing
Charleston, South Carolina

Printed in the United States of America

Library of Congress Control Number: 2010934473

For all general information, please contact Arcadia Publishing:
Telephone 843-853-2070
Fax 843-853-0044
E-mail sales@arcadiapublishing.com
For customer service and orders:
Toll-Free 1-888-313-2665

Visit us on the Internet at www.arcadiapublishing.com

This book is dedicated to the thousands, perhaps millions, of volunteers at various historical societies–locally, nationally, and worldwide—who have given their time and energy to preserving the historical aspects of their particular area. Without their dedication, much of our history would be lost forever.

CONTENTS

ACKNOWLEDGMENTS

Authors never work alone; they always have help. My help for this book came primarily from the three dedicated volunteers at the Gresham Historical Society who arrive every Tuesday, Thursday, and Saturday and open the doors of the building for persons asking a myriad of questions regarding the area's local history. They leave with their requests fulfilled. I have found the knowledge of Utahna Kerr, lead historian for the Gresham Historical Society; Tom Metzger; and Martha Ruegg to be invaluable in helping me select the photographs for the book and, most of all, writing the captions. Their ancestors cover many years in the area's history. There were other volunteers who also helped whose names I do not know.

I am indebted to Sharon Nesbit of the *Gresham Outlook* for providing valuable assistance in previewing my initial attempt. An author herself, she commands a broad understanding and knowledge of the area's history.

Throughout all of my authorships, my wife, Janice, has given many hours in proofreading the text. Her knowledge of grammar and style are invaluable.

Publishing with Arcadia has been a new experience. Donna Libert was the editor assigned to my Gresham project. I had many questions and she quickly answered all of them, although some must have seemed trivial. She was just a super coach, and I am indebted to her.

Except where noted, all photographs are from the Gresham Historical Society's photograph files.

INTRODUCTION

The Corps of Discovery journeyed down the Columbia River in the fall of 1805. Their return trip brought them again through the land in the spring of 1806. Meriwether Lewis and William Clark noted in their journals that the area looked rich in agricultural potential. They also mentioned the endless forests of huge trees.

In 1847, John, Jackson, and Dave Powell joined an emigrant train bound for the Oregon Country. After traveling down the Columbia River, they stopped at what was to be known as Troutdale, north of Gresham on the river. They spent the winter at the mouth of the Sandy River, rolling logs down the Columbia to a government sawmill in the Vancouver area. Jackson Powell joined the gold rush to California in 1848 but returned in 1851. He took up a donation land claim in the area.

In 1852, James Powell followed his brother to the area. He brought with him his wife, Eliza, and her two sisters. James purchased his donation land claim next to that of his brother's. It was for Eliza Powell that Powell's Valley was named. She was affectionately known as "Aunt Eliza Powell" and regarded as the first white woman to make a home in the area.

Other early settlers arrived in the area via the Barlow Road. Their last stop was at Phillip Foster's home in Eagle Creek, southeast of Gresham. It was also a tollhouse but a welcome stop after an arduous and treacherous journey over the Cascade Mountains before entering the fertile Powell's Valley. Portland, Oregon, 11 miles to the west along the Willamette River, was already a growing community.

After Oregon received its statehood in 1859, the area that was to be known as Gresham saw numerous settlers move in—Powells, Metzgers, Roberts, Shattucks, Johnsons, Linnemanns, Rueggs, Slerets, and many others. (The names are familiar to people today.) They either purchased donation land claims themselves or from others. These pioneers soon learned that the area was rich in agriculture potential. But before that aspect could be developed, the forest had to be cleared. Small lumber mills developed throughout the region as the forests were cleared in preparation for the agriculture that was soon to begin.

As this book will show, dirt and muddy streets soon became gravel and thence paved. Schools were built to accommodate the growing number of new residents. Businesses were developed so citizens would not have to travel the dangerous road into Portland. Some disasters occurred, but residents found many ways to enjoy themselves. Not all aspects of the town could be put into these pages, but it is hoped it will give readers a glimpse of the town as it was developing.

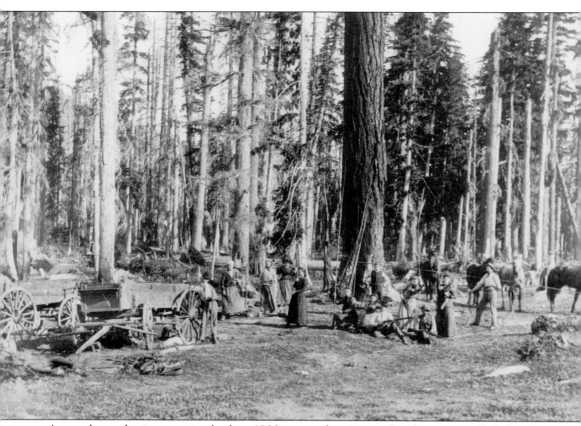

A popular gathering spot in the late 1800s near what is now Gresham was called the Camp Ground. It was a place where people met on a Sunday afternoon. Hundreds of teams of horses and wagons lined the dirt street as visitors came out from Portland. According to recollections of Marion Dudley Eling, the Camp Ground was located in a stately grove of fir and cedar trees at the current intersection of Main Avenue and Powell Boulevard. Indeed, Gresham, before it was officially named, was called Camp Ground and Powell's Valley. The majority of the trees were blown down during a fierce windstorm on January 9, 1880.

One

STREET SCENES AND TRANSPORTATION

What did Gresham look like many years ago? Towns change remarkably over the years. Buildings that once stood are no longer there. Streets are changed, widened, and in some cases eliminated. In most instances, what one views today is not how it looked when the town was in its early stages. Such is the saga of Gresham. Very few landmarks that were present at the start of the 20th century exist at the start of the 21st. Methods of transportation also changed over the years. This transition is noted in this chapter and in other photographs throughout the book. It is interesting that the town of Gresham was the first community outside the city of Portland to receive MAX, or Metropolitan Area Express light rail in the late 1980s. Yet in the early 1900s, Gresham was connected to Portland and several other towns in east Multnomah County via an electric rail system that carried hundreds of people. Maybe some things do not change.

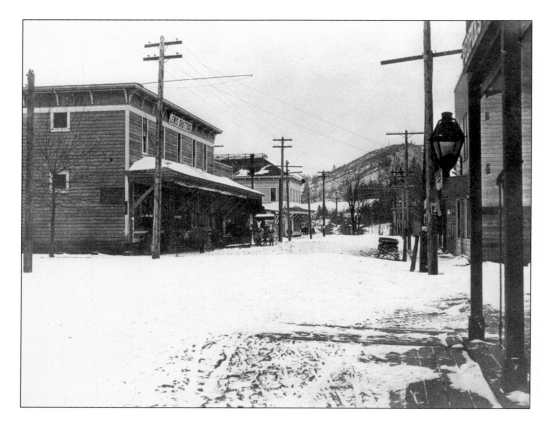

This photograph was taken in the late 1890s. It shows Main Avenue looking south toward Gresham Butte, which was clear-cut of its trees. The building on the left is the old Shattuck store. Planks in the lower right act as a boardwalk. The bottom photograph was taken later, around 1919, and also looks south. The cross street is probably North Third Street. Dee's Photo currently lies on the southwest corner of Main Avenue and Second Street and Boccelli's Italian Restaurant is on the southeast corner.

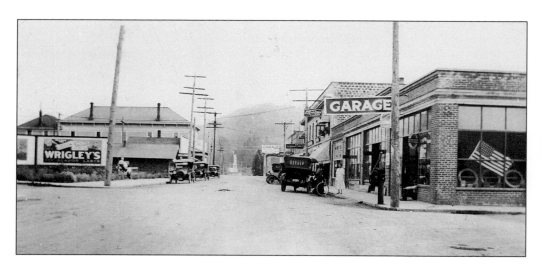

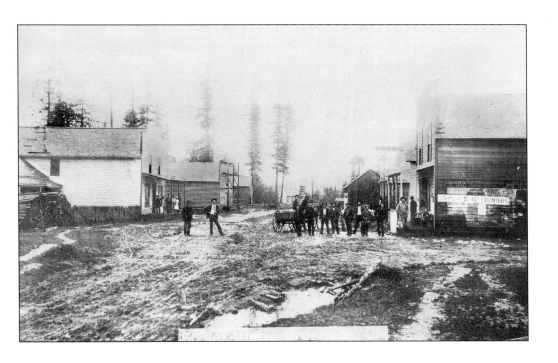

These two photographs are both looking west along Powell Boulevard. Main Avenue is shown coming from the north in the above photograph taken in the late 1800s. In the distance, the old school with a gingerbread tower is faintly visible. The photograph below was taken much later and from a location farther west. Trinity Lutheran Church now occupies the vacant area just east of the white house that still stands on the northwest corner of Eastman Parkway and Powell Boulevard. It was the home of H. E. Davis. The West Gresham Grade School was built just out of the newer photograph, in the lower left.

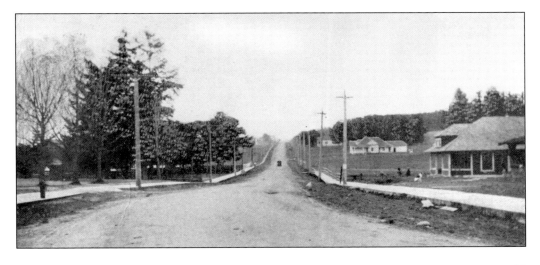

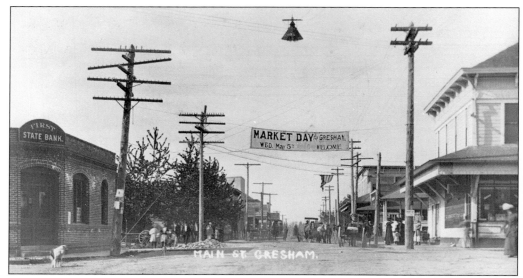

The intersection of Powell Boulevard and Main Avenue occupies the lower center of this photograph. First State Bank, Gresham's first bank, is located at the left, and the Congdon Hotel would be built in the area where the grove of trees is located. Horses and bicycles are the favored methods of transportation, but electricity has been added. Streets are still unpaved. The two buildings on the right are the Shattuck Building and the John Metzger Building.

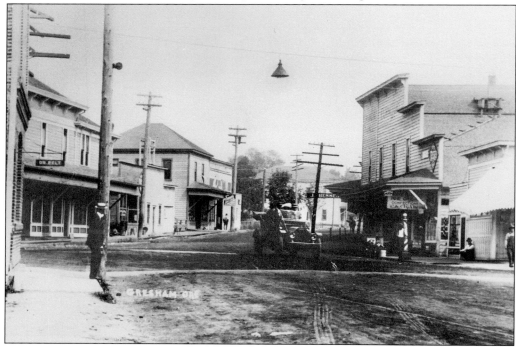

Streets remain unpaved in this c. 1911 photograph of Powell Boulevard looking east. The automobile is apparently a 1911 Bentley. The gentleman near the power pole at the left is Charlie Rivers, likely Gresham's first black person. The crosswalks were probably heavily used or had been covered with boards. The building on the left is a drugstore.

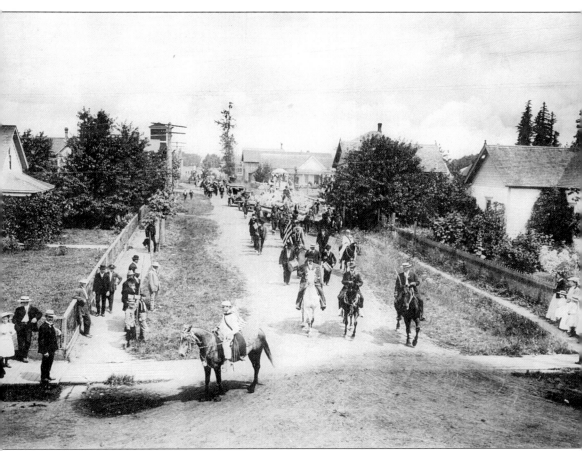

North Roberts Avenue is shown at the intersection of East Powell Boulevard during the Fourth of July parade in 1907. A float is barely visible in the very center of the photograph. Jacob Metzger is the individual standing on the left corner facing the camera. He was responsible for many of the houses built in early Gresham, including his home, which was modified to become the Truffle Hunter Restaurant today.

This intersection of 190th Avenue and Powell Boulevard has changed considerably. A railroad repair crew crosses Southeast 190th Avenue. The Cedarville store and gas station are on the corner. When Powell Boulevard was straightened, this dangerous curve was eliminated as were the store and filling station. This portion of Powell Boulevard is now called Powell Loop. The sign points to 190th Avenue and Damascus. The Springwater Trail now occupies the railroad right-of-way. (Photograph courtesy Oregon Historical Society; OhHi Negative #bc005931.)

Cor. Powell & Main St. Gresham Ore.

The fountain at the intersection of Powell Boulevard and Main Avenue was originally built as a watering trough for horses (above). Later a duplicate of the *Statue of Liberty* was added to the top of the fountain and called *Her Goddess*. She is looking north. As more automobiles came into Gresham's transportation, the fountain became a hindrance to travel and was repeatedly struck by cars. It was removed in the early 1920s, and its whereabouts are unknown, but theory has it that it was part of the fill-in when Powell Boulevard was straightened. The large white building (above) on the corner is the Withrow Building at the southeast corner of Main Avenue and Powell Boulevard.

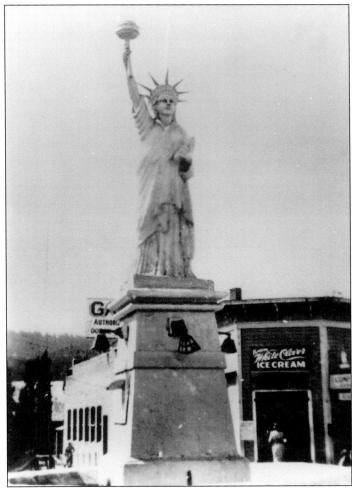

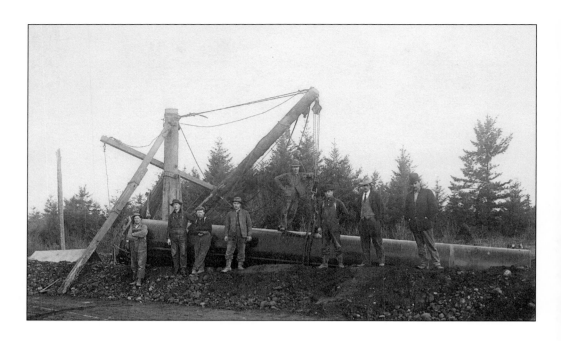

Construction of the Bull Run Reservoir pipe carrying Portland's water supply started in 1893. This pipe to Portland passed directly through Gresham. Underneath the city in the vicinity of First Street, the pipeline is in existence today. Originally, Gresham decided not to connect, thinking Bull Run water was not pure enough. In 1910, however, Gresham agreed to tap the line at the cost of $35,000 to the city. Water began flowing through the new pipe on September 1, 1911. It now is listed as the purest nature can offer.

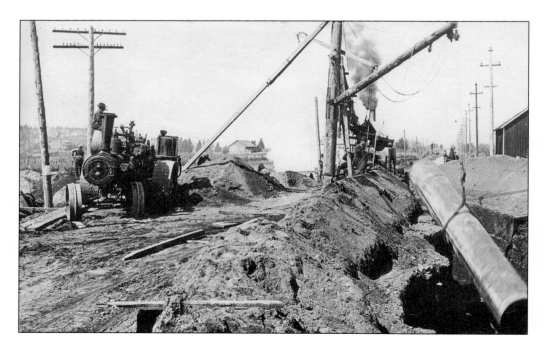

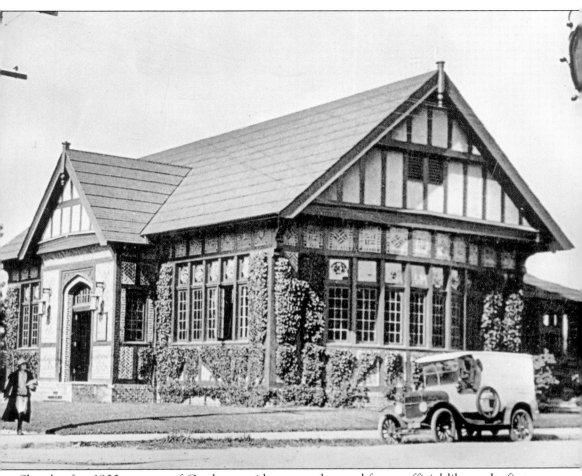

Shortly after 1900, a group of Gresham residents saw the need for an official library. Its first permanent location was above the post office, and library cards could be obtained from the postmaster, Iona McCall. She donated the first 50 books, and others were then brought in from the Portland library. The first official building to house only the Gresham Library was built in 1912 and was dedicated in 1913. Andrew Carnegie, who donated monies for libraries nationwide, provided the funding. The land at the northeast corner of Fourth Street and Main Avenue was purchased for $1,900. The total cost of the building was $11,568 plus $1,756 for equipment. Folger Johnson designed it with help from local citizens. The style of architecture is Tudor. Modernization occurred in 1961 at a cost of $41,000. At that time, it served a population of around 10,000. The library was in continuous use until 1990. The Gresham Historical Society moved into the building shortly after 1990, when a new library was built on Miller Street.

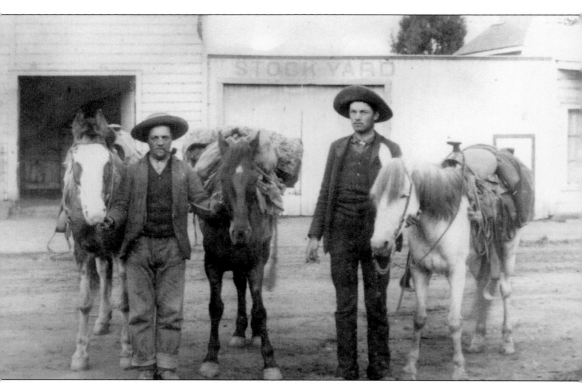

In the late 1800s, there was no local place to purchase needed supplies for an area that was seeing additional settlers. Only Portland, to the west, had stores offering provisions. It was a long and often dangerous trip over the 11 miles into Portland. Bears, cougars, and wolves still roamed the country. Supplies were loaded on packhorses, and usually two or more folks went on the trip that lasted an entire day. John Shattuck is shown in this c. 1890 photograph with an unidentified friend ready for the long trip to the city. Shattuck lived off West Powell Boulevard.

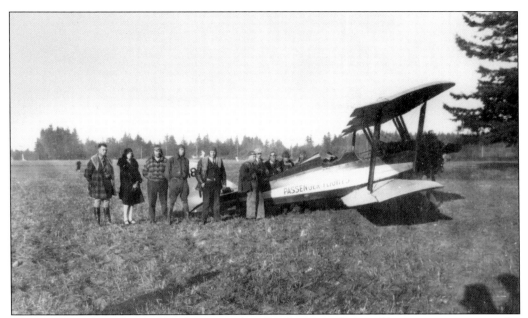

There was no formal paved landing strip, but Gresham can boast of having an airport in the 1930s and 1940s. It was located west of 181st Avenue, between Division and Stark Streets. The property at that time belonged to Henry "Hank" Troh. During World War II, he trained pilots at Tulare, California. He returned to Gresham after the war and applied for an official license, which was denied because the airport did not have a north-south runway. That was later obtained when the Rueggs, who owned property along 181st Avenue, allowed Troh to build the runway on their land. As the area grew in population, there was some objection to the airport, and the property was subdivided in the late 1950s.

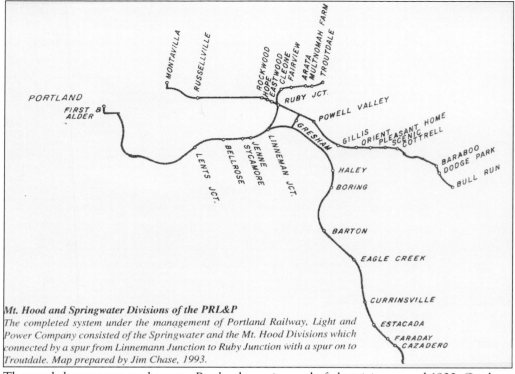

Mt. Hood and Springwater Divisions of the PRL&P
The completed system under the management of Portland Railway, Light and Power Company consisted of the Springwater and the Mt. Hood Divisions which connected by a spur from Linnemann Junction to Ruby Junction with a spur on to Troutdale. Map prepared by Jim Chase, 1993.

The much larger town to the west, Portland, was in need of electricity around 1900. Gresham was fortunate to be close to a rail line that was constructed to bring supplies to a dam being built on the Clackamas River. That line reached Gresham in 1902, and in 1903 it was completed to the dam site, Cazadero, south of Estacada. Supplies of all sorts, including groceries, hardware, finished goods, and newspapers, found their way to the Gresham area via this line. Special trains like the one shown in the photograph later ran along these rails to Cazadero and other places between Gresham and the dam.

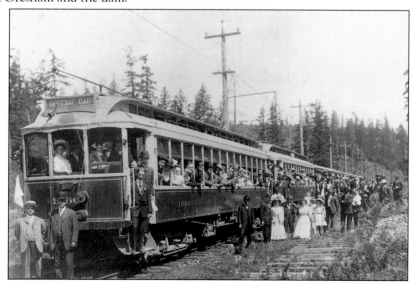

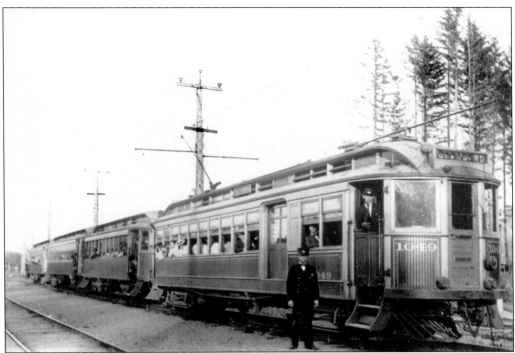

Service began on a spur line from the Linnemann Station to Troutdale. The spur was completed in 1906, and other stations sprang up along that line. A depot for Gresham was being planned for a site in between Roberts and Hood Avenues, fronting Division Street. The changes this electrical car system brought to Gresham were astounding. No longer would supplies have to be brought in by a day's journey to Portland by pack mule or a six-hour or more horse-and-buggy ride. Affluent Portlanders soon built summer homes along the line, and others seeking the solace of the country did the same. Completion of the Bull Run Reservoir saw the line expanded from the Linnemann Station. This was called the Mount Hood Division.

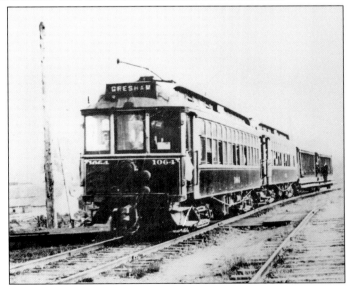

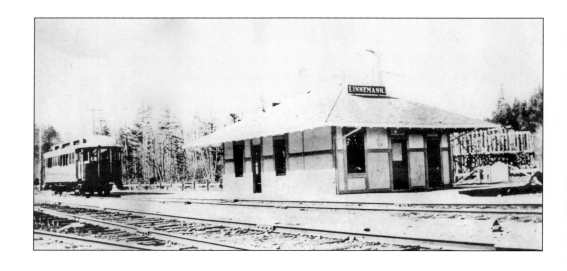

The Linnemann Station was a major stopping point along the Springwater Division, as the line through Boring to Cazadero was called. Within walking distance or a short buggy ride from most Gresham locations, it became a hub of activity. The station was a popular gathering point for folks to socialize while waiting for the mail and the *Oregonian* newspaper from Portland. Today the rail line no longer exists, but thousands of people use the right-of-way for walking, jogging, and bicycling along what is called the Springwater Trail. The Linnemann Station deteriorated rapidly after the demise of the trolley system, but it was built anew and still serves as a hub for people enjoying the now paved Springwater Trail.

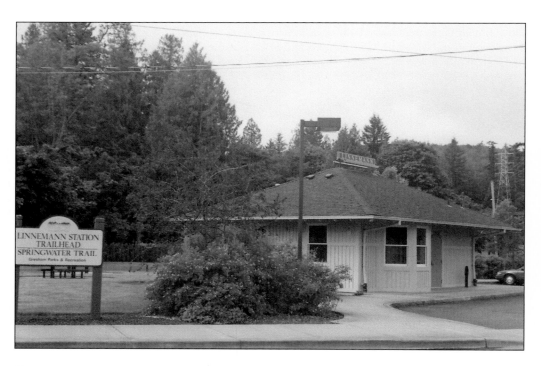

Two

SCHOOLS AND EDUCATION

At first the children who traveled from the east helped their parents as they had done on the long journey west. But when the land was cleared and homes were built, education raced to the forefront. The majority of children, having come from areas in the Midwest, could already read and write. But they needed more instruction.

In 1852, settlers in the Pleasant Valley area saw the need for a schoolhouse. Several families collected $300 and in 1857 built a school just to the southeast of where the current Pleasant Valley School stands today. (The area may soon become annexed as part of Gresham.) It was one of the first schools in Multnomah County, but others soon followed. One of particular interest was built on Powell Valley Road in 1874. Called the "white school house," it was used as a church as well as a school. It lost its roof during the terrible storm of 1880 and was mostly burned soon thereafter, but it was rebuilt at the location where the West Gresham Grade School is today. Other small one-room schoolhouses were built in the area. As transportation improved, however, smaller one-room facilities were replaced by larger schools and districts consolidated.

Around 1900, children rarely proceeded beyond the eighth grade. Thus, there were many graduation ceremonies in the early 20th century. Ten students were among the class of 1902. Many young people, especially boys, then began helping their parents with agricultural duties. Indeed, for 50 years, from around 1850 to 1900, there was not one school in east Multnomah County that went beyond the eighth grade.

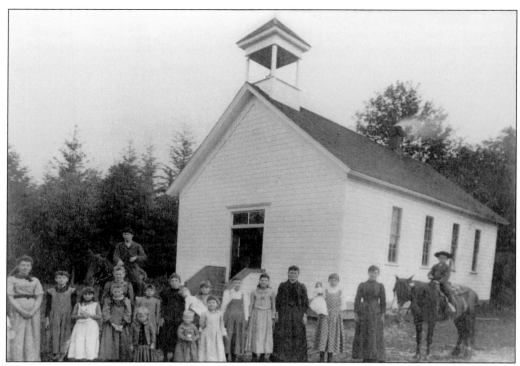

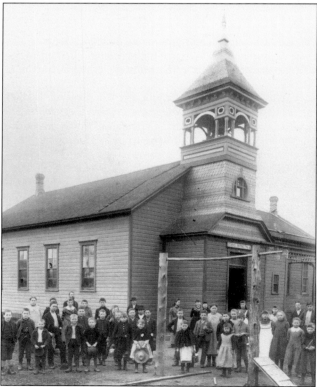

The one-room schoolhouse built in 1874 housed all grades and was often called the "white school house." After suffering damage from both the 1880 windstorm and an 1882 forest fire, the school was rebuilt. In 1891, it was enlarged, and the gingerbread tower was added as well as a sign indicating it was School District No. 4. The structure's duty as a schoolhouse ended shortly after 1900, and it was moved about 150 feet east and became the home of the Gresham Grange. It was later torn down. At its former location, a more modern three-story schoolhouse was constructed, the first to have indoor plumbing. Today the West Gresham Grade School occupies the site. The names of the children in the picture at left are too numerous to include here but are recorded on the original photograph at the Gresham Historical Society.

Many frontier schools used the same style of construction as this one in Rockwood. It was situated on the northeast corner of 181st Avenue and Stark Street, where a bank is located today. The photograph with the child seated on a stump (below) was reportedly taken on July 21, 1909. The man directly behind the child is John Grown. Schools often had multiple uses at that time, as places of worship and for other activities. The rope seen in both pictures was used to ring a bell.

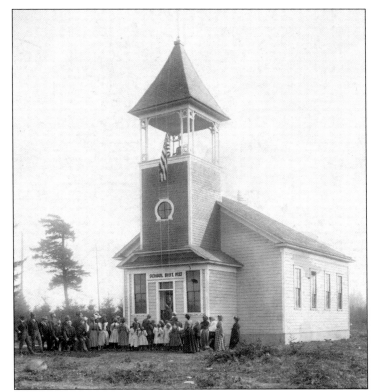

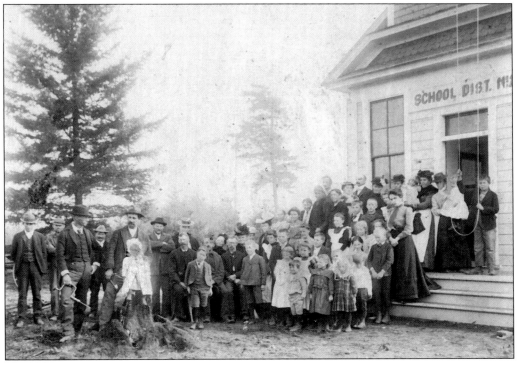

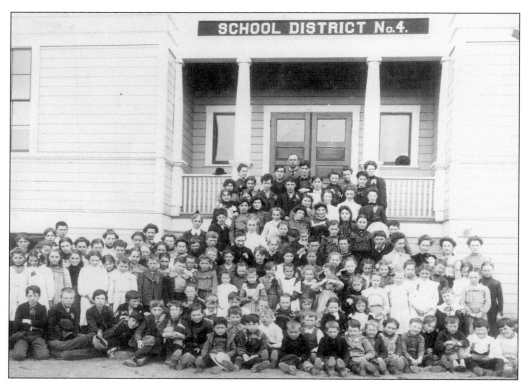

The fourth schoolhouse in Gresham had been expanded in 1901 to three floors so it could house more students. Over 80 students and teachers are shown in the photograph above. Their names are too numerous to include in this publication, but they are on file at the Gresham Historical Society. Until 1902 there was no high school. The following year, a ninth grade was added, with an additional grade each year thereafter until 1906. Two students, Grace Lawrence and Pearl Lindsey, were the first to graduate from high school. That was in 1906. The high school was located on the top floor of the building. One class (below) is shown on the steps of the school around 1909. The teacher has been identified as Clara Anderson.

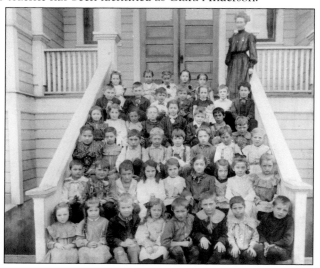

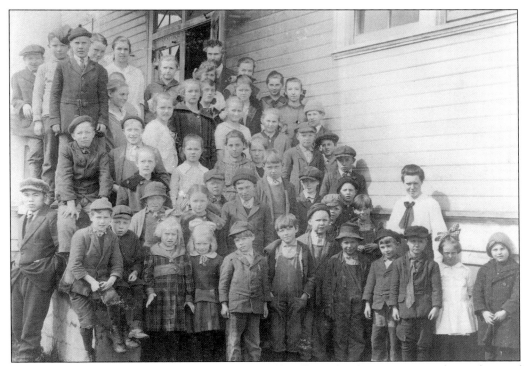

The school shown in the photograph is the Powell Valley School in 1919. It was located east of Gresham and contained several grades. George Metzger is the teacher at the very top in the center. The unidentified lady in the lower right may be the teacher of the younger students.

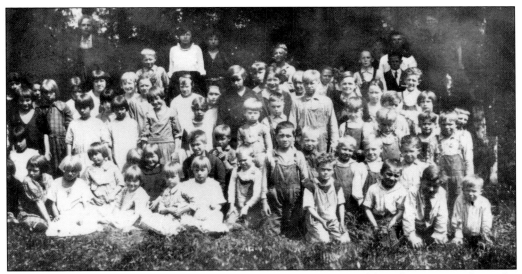

This photograph, also of the Powell Valley School, was donated by Ellen Wasser from the collection of Gladys Richey. It is from a much later date, probably in the 1930s. The students are unidentified.

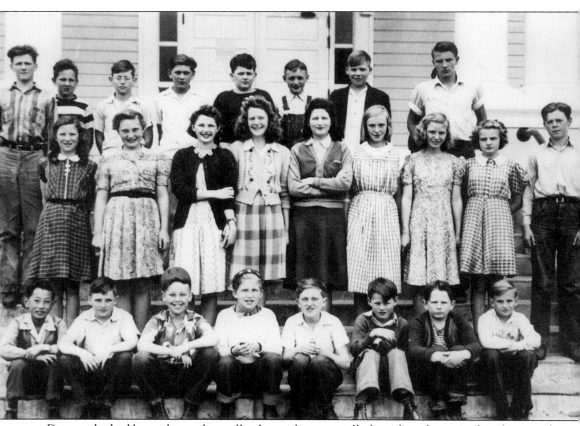

Dress codes had been changed as well as hairstyles, especially for girls as shown in this photograph of the Powell Valley School in 1941–1942. In contrast to earlier photographs, most of the students are smiling, whereas in older photographs they appeared with stern faces.

George Metzger was often thought of as a strict teacher, and students rarely varied from the standards he set. In this photograph are, from left to right, (first row) Clifford Ekstrom, two unidentified, Metzger, Genevieve Manary, and Carl Nordblum; (second row) Leonard Nelson, Vera Salquist, Audrey Johnson, Emery Keller, Pearl Gustafson, Ann Lind Pankratz, and Sven Nelson.

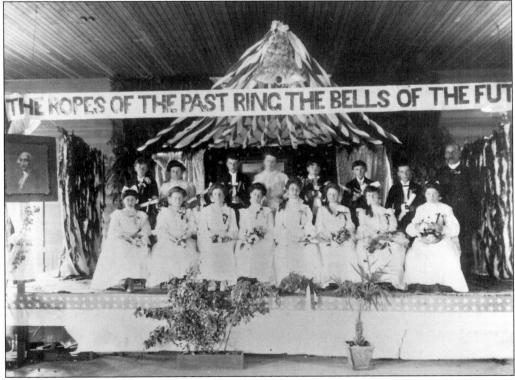

This photograph is of the Gresham eighth grade. The students are, from left to right, (first row) Janie Ross, Jean Miller, Mae Durrell, Mary Shattuck, Edith Gordon, Dilla Gould, Daisy Smith, and Alta Chapman; (second row) Otto Waffles, unidentified, Ed Metzger, Lula Smut, Roy Chalker, Clara Waffles, and Charles Cleveland. The teacher is a Professor Hershner.

The photograph above is the seventh-grade class from Mrs. Schneider's room at Gresham Grade School in 1933–1934. The entire 1945 eighth-grade class at the Gresham Grade School is shown below.

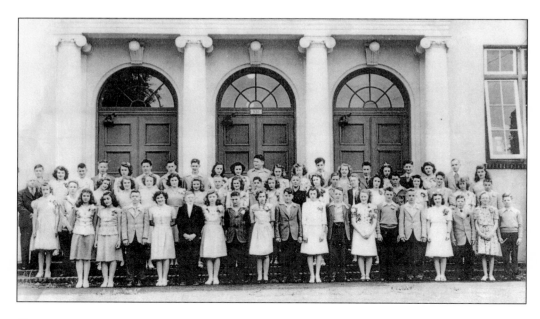

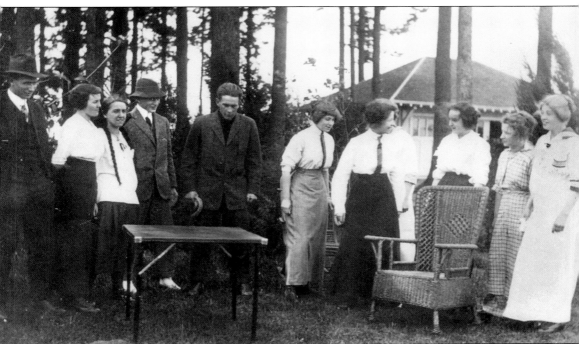

The 1914 class of Gresham High School consisted of 14 students. They are attending a graduation party above with their instructors. A total of 72 students had graduated from Gresham High School since 1906 at that time. In 1915, that high school district combined with other high schools in the area—Lynch, Powell Valley, Terry, and Hillsview—and a total of 25 students graduated. Lynch was west of Gresham, and Terry was a small school along Stark Street near where the present Mormon church is located. Hillsview was another small school, south of the Persimmon Golf Course near Borges Road. The present Gresham High School on Main Avenue was completed in 1915. Since then, several additions have been added mainly by the Work Progress Administration (WPA) in the 1940s.

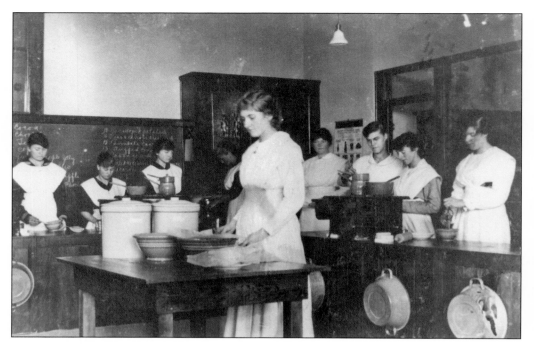

Home economics classes had become very popular in high school prior to 1920, as this photograph of the 1917 class shows (above). The 4-H canning classes in the 1930 picture (below) shows ladies sitting at the table sorting what appear to be berries and inserting them in the jars. Another, standing, is peeling what appear to be root crops of some sort.

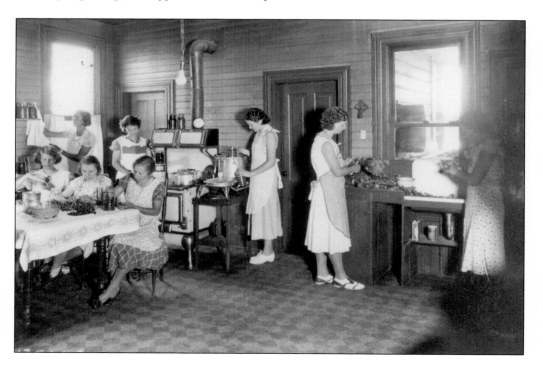

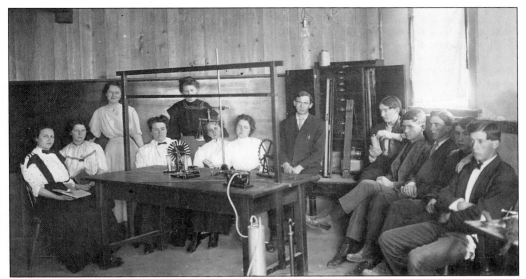

This photograph of the Gresham High School chemistry class of 1910 shows a group of students led by their teacher, a Mrs. Woodward. The students are, from left to right, Stella Roper, Alma Daily, Bess Osborn, Mrs. Woodward, Mary Harvey, Ethel Calkins, Earl Thompson, Dan Lynch, Bert Hoss, Earl Clanahan, Charlie McCall, and Kenneth Roberts. The lady standing third from the left is unidentified but could be an assistant teacher.

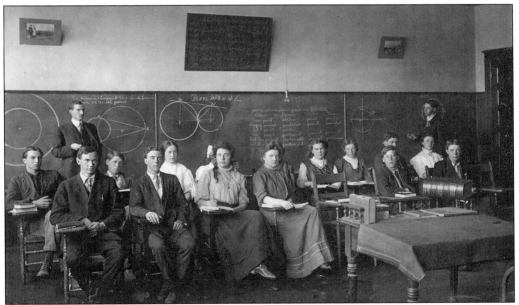

This Gresham High School math class appears to be around 1910 since some of the same students are shown in this photograph as in the chemistry class. They are, in no particular order, Earl Thompson, Earl Clanahan, Maude Mitchell, Marian Roberts, Roy Johnson, Blaine Turner, Harold Wilson, Wilbur Thompson, Mae Kesterson, Lillian Freedolf, Maizy Schan, Bert Hoss, Ethel Wilkerson, and Kenneth Roberts. Professor Baker is the individual standing at the left. At least one student is partially hidden behind the third student from the left in the first row. The person standing at the blackboard on the far right is unidentified but could be an assistant teacher.

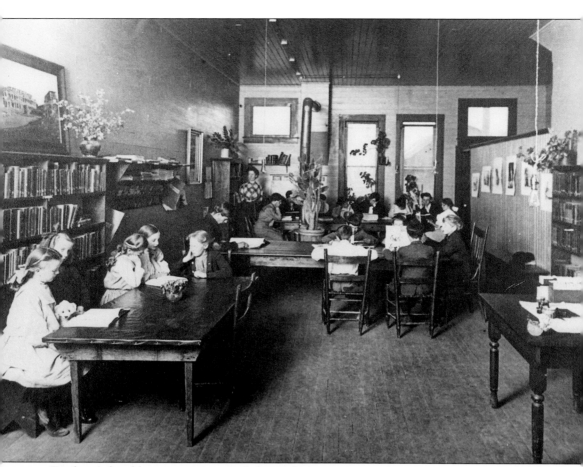

Gresham's first library was temporarily located upstairs in a store on Main Avenue around 1900. Many settlers to the area had brought a few books with them across the plains and mountains. They generally came from areas in the Midwest and East and believed that libraries and continued learning were of great importance. Other books were probably acquired from Portland's library to the west.

Three

DISASTERS

As with most towns in the early 1900s, disastrous fires occurred in Gresham. Most buildings were constructed using wood products produced locally. Perhaps the worst fire was the December 1914 blaze that consumed a large portion of downtown. It was the third major fire in 13 years to hit the Gresham area. Other large blazes throughout the years included those at a Ford dealership and at a cannery.

The Pacific Northwest is not noted for its snowstorms, yet they do occur. And when they do, the area often becomes immobilized. East winds bring cold air that migrates down from Canada into the Gresham area and causes drifting. The author recalls talking with the Wogsbergs, who had a farm north of the subdivision where he settled. Harold mentioned that both 190th Avenue and Pleasant Valley Drive were frequently drifted over in major snow storms. And if it was not snow, when warm air arrived from the southwest, freezing rain coated streets, buildings, power lines, trees, and so forth with ice.

Major windstorms have also caused destruction in the area. As previously mentioned, the January 9, 1880, storm literally blew down thousands of trees in the Portland area and made travel almost impossible. Again, on October 12, 1962, and November 13, 1981, the area was visited by violent winds. Even weak tornadoes, more common in the Midwest, have visited the Gresham area.

Johnson Creek, a tributary of the Willamette River to the west, has flooded many times over the past. Engineers changed the course of the creek, which at one time flowed into the downtown area immediately south of Powell Boulevard where Main City Park is today.

This chapter touches on a few of these events.

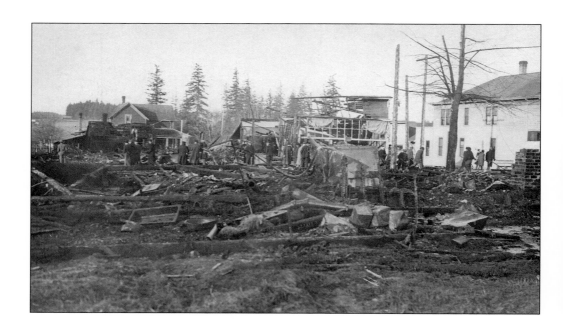

This fire on December 20, 1914, originated in the Shattuck Building around 3:00 a.m. At the time, it was the largest store building in eastern Multnomah and Clackamas Counties, with sales as high as $15,000 a month. Strong east winds carried embers across the street, and the temperature was in the upper 20s. Damage estimates ranged as high as $40,000, as nine buildings on Main Avenue between First and Second Streets were destroyed, with others suffering some damage as well.

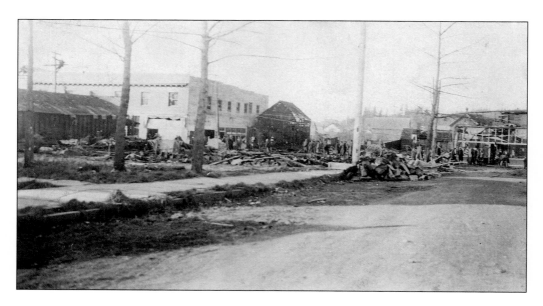

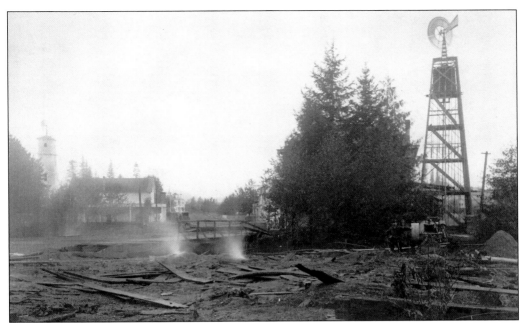

The Bartelt Mercantile Company suffered the greatest damage in the December fire. John Bartelt was sleeping on the second floor of the building, and flames prevented his escape down the stairs. He was rescued when a ladder was hoisted to a second-story window. A fire truck was dispatched from East Thirty-Fifth Street and Belmont Street in Portland and arrived within 20 minutes. It was credited with perhaps saving the Congdon Hotel across Main Street. Ice hampered fighting the fire, and those involved said that water froze to their clothes.

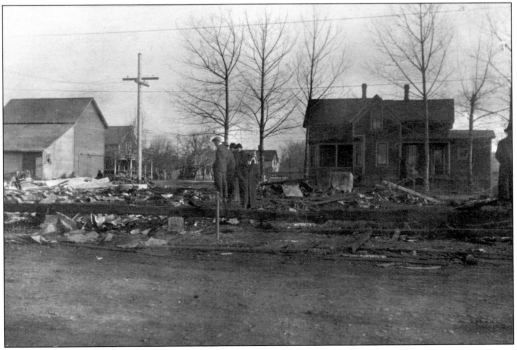

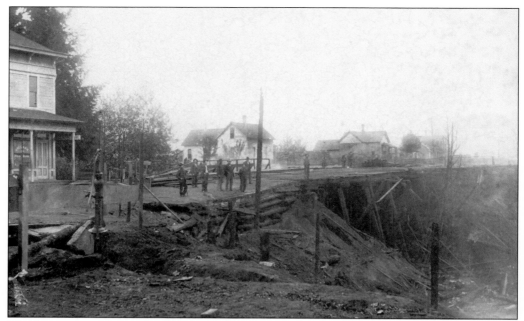

The fire, or most likely a flood in this picture, occurred around 1900. Powell Boulevard is shown with the Gresham Drug at left. At the time of the photograph, Johnson Creek wound its way very close to Powell, and pilings supported a portion of the roadway. Buildings erected later were supported by pilings.

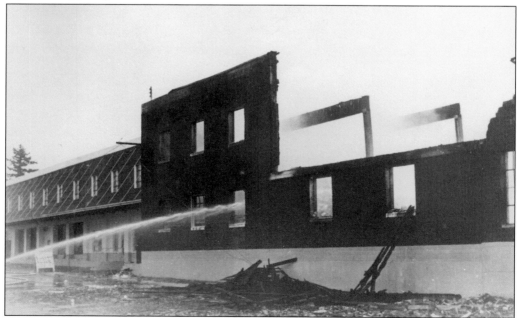

There were no treats for the Flav-R-Pac cannery on Halloween night 1976. A huge blaze consumed the 95,000-square-foot building. The biggest loss was government surplus powdered milk valued at $4 million. The fire burned for several hours before it was brought under control and left a smoky stench over the city of Gresham. Four firemen were hurt while fighting the blaze.

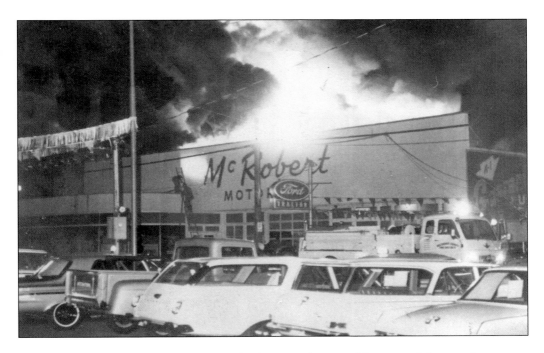

Early in the morning on June 4, 1963, a fire broke out in the rear of the automobile parts department at McRoberts Motors. The Ford dealership had been in existence for 33 years. At the time, it was the costliest fire in Gresham's history with damage assessed at $300,000. Fire crews from Portland, Parkrose, and Districts 13 and 14 helped fight the three-alarm fire. At the height of the blaze, 14 pieces of equipment were on hand. Arson was suspected as the cause.

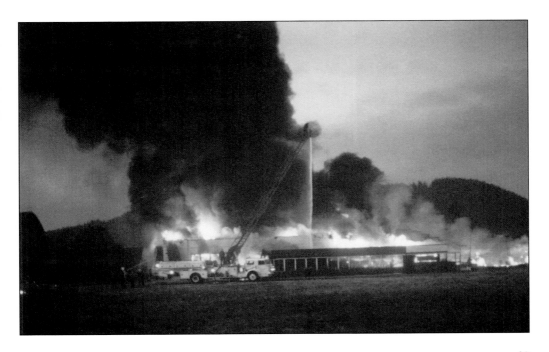

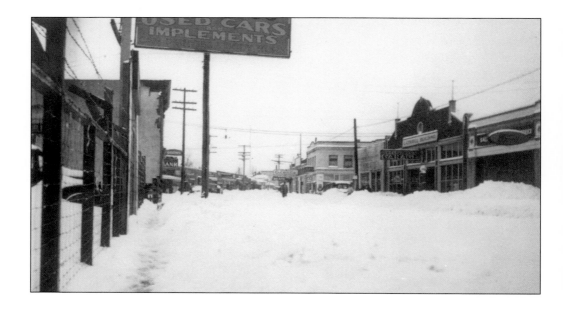

Early settlers to the Pacific Northwest remarked that a terribly cold and snowy winter would come about every 15 to 20 years. Unlike towns where snow accumulation is expected in the winter months, snow in western Oregon towns causes major problems with transportation. The above photograph shows Powell Boulevard looking east around 1932. The photograph below shows Main Avenue looking north in 1919.

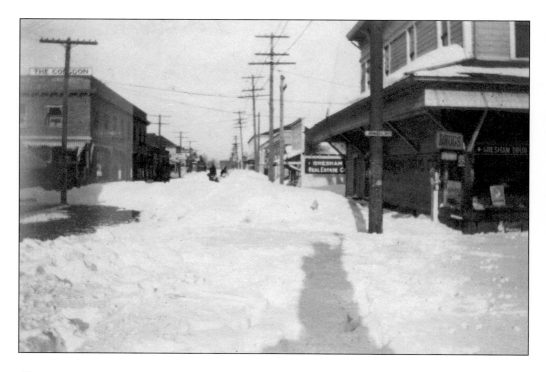

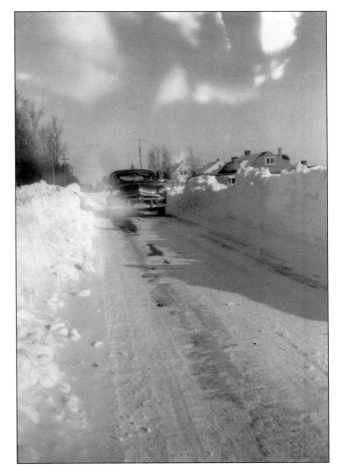

Located at the west end of the Columbia River Gorge, the Gresham area usually gets snow on a strong east wind. Such gales cause drifting of the snow, as seen in these two photographs. The Ford car is driving down a road that was closed and then plowed open (at right), leaving snow banks on either side during the winter of 1946–1947. The photograph below was taken in 1916 at the old Roberts home located on the north side of Powell Boulevard between Wallula and Birdsdale Streets.

a Snow pile

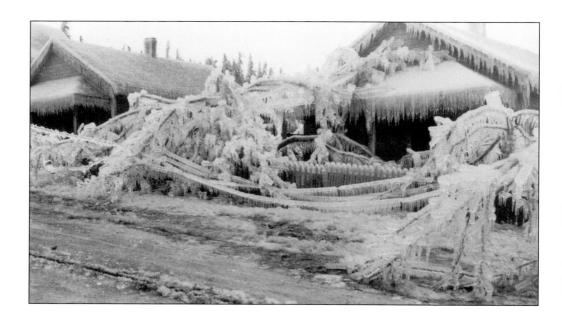

Not only did Gresham residents not look forward to major snowstorms, but they also feared the "breaking up" of the cold snap. The situation of cold, heavy air at the surface when warm moist air moves in overhead normally produces freezing rain, as liquid rain drops fall into the cold air with a temperature below freezing. The rain then freezes on whatever it comes in contact with, as both photographs show. The term has often been called a "silver thaw," indicating that warmer temperatures and a melting of the snow and ice are soon to follow.

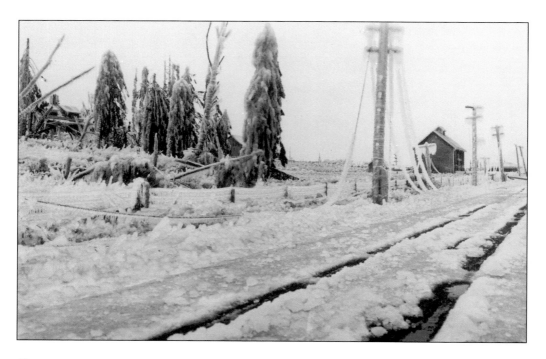

These two maps show the course of Johnson Creek in the first half of the 20th century. It made a sharp turn to the right and flowed in a loop in proximity to Powell Boulevard, through what is now Main City Park. Water spread over the lowland where several buildings, including the Welty residence, were located. Originally Main Avenue extended south of Powell Boulevard and a footbridge crossed Johnson Creek. The map at right depicts the creek as it flowed through the town and also the location of the Multnomah County Fairgrounds, where a shopping center now exists, bordered by Eastman Parkway. The more detailed map (below) was drawn by Jim Chase, and the other is from the Gresham Historical Society archives.

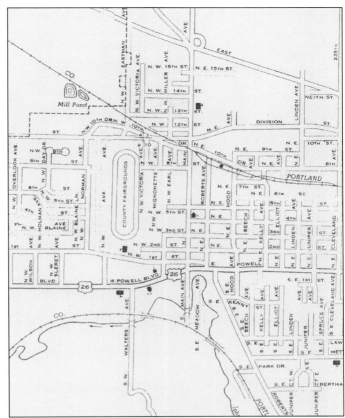

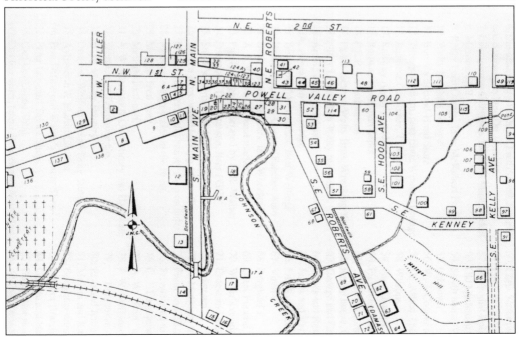

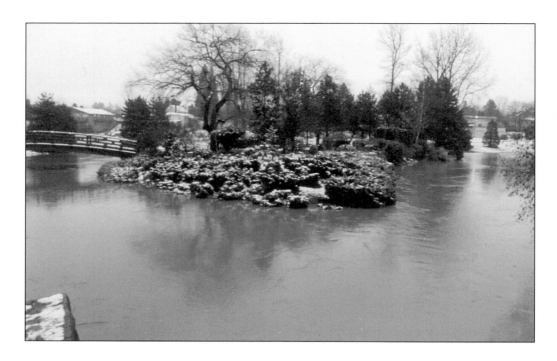

These two photographs, taken by the author, show the course of Johnson Creek during the flood of February 1994. The water flows around the island and under the footbridge. A substantial amount of wet snow had fallen, and most of it melted under a warm heavy rain. One can only speculate what damage would have been done had the creek followed its original course.

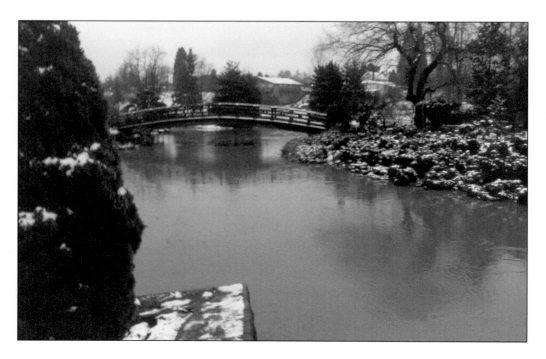

Four

RECREATION

The first fair held in Gresham was October 16–19, 1907. The location was in an area called The Flats, slightly west of Main Avenue and south of Powell Boulevard. This fair was sponsored by the Gresham Grange. Years prior to the first fair, some rivalry had been created between farmers as to who had the best cattle or produce. The fair was a place to showcase these farm products. The following year, a fair board was created, and the site was moved north and slightly west. That would be its home for the next 61 years. It became known as the Multnomah County Fair and drew people from all over southwest Washington and northwest Oregon. The date of the next year's event was soon set, and patrons were advised to mark their calendars.

The fair grew in size and also in duration, from 3 days to 5 and eventually to 10. Activities also were increased. Animal exhibits and agricultural products and machinery became an integral part of the annual event. A racetrack was added, as well as a carnival and military exhibits. Living in east Multnomah County, a person simply did not want to miss the fair. Today Eastman Parkway and a shopping center occupy the site.

But that was not the only form of entertainment in the town. As schools grew in size, sports were added. Ball teams were organized both within the schools and outside. Girls hose teams were organized that competed pulling fire hoses to a set location. They traveled throughout the area, going as far away as Astoria. And there were celebrations, as noted on the cover of the book, including parades and rodeos. Hopefully this chapter will bring back fond memories of each of these events.

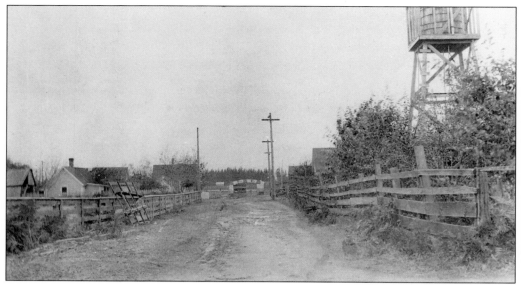

It was only a dirt road that led to the location of the first fair in Gresham south of Powell Boulevard. With the creation of a fair board, the event became more organized, and the date was changed. Dirt roads can become very muddy in October, and for the following years much earlier dates were explored—from mid-August to mid-September.

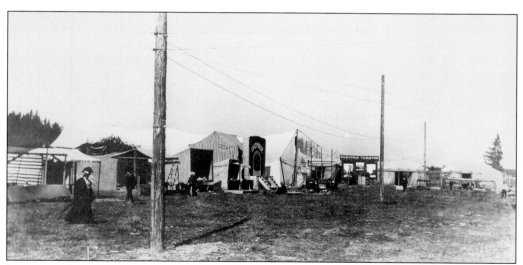

Large tents housed the attractions at the first fair, and only after the site changed were permanent structures built. Still, some events always found at a fair, such as games and farmers showing off their animals and produce, were in existence.

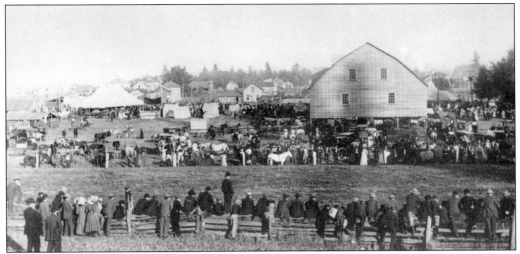

This building was the first permanent structure erected at the fair after it moved from its first location. Tents can be seen in the left portion of the photograph as can as horses and buggies. People circle a field that probably was the showing area for animals and perhaps what eventually would be a racetrack. And indeed a racecourse was added in 1911 along with a grandstand.

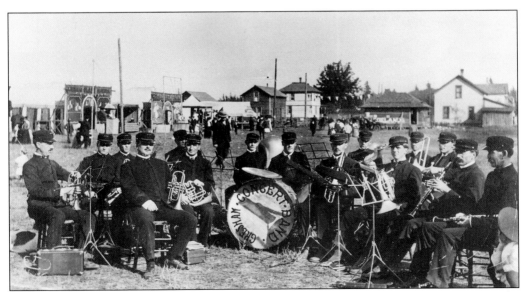

What is a fair without musical attractions? With members dressed up in their finest attire, the local Gresham Concert Band played at the fair. This photograph, taken years after the fair was moved, now shows more permanent structures. Earlier dates, such as in August, allowed activities to occur outside without much threat of rain.

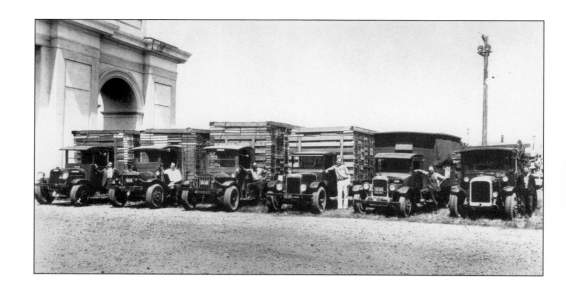

At the left of the above photograph, a portion of the main entrance to the fair can be seen. Numerous vehicles would be used to supply the event with produce, goods, and, most likely, livestock. Fairs would also bring cars in from all over the area, as they were rapidly becoming a favored method of transportation. But with the electric trolley system in place, that allowed vast numbers of people to arrive without the need for an automobile.

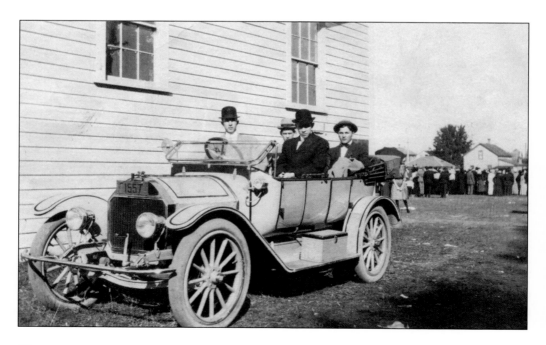

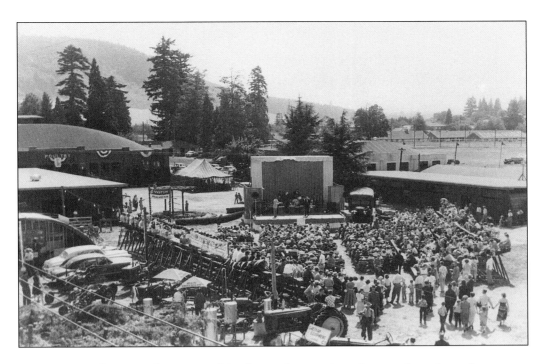

Entertainment became a large part of the fair, and entertainers known throughout the country were brought in to perform. One such group was the Nitty Gritty Dirt Band, featured in the movie *Paint Your Wagon*. Those performances were usually packed, and people mostly stood watching and listening. The fair often attracted celebrities, as evidenced in the photograph below showing Teddy Roosevelt Jr. greeting a little girl. Hollywood, with a crew of 35, came to the site in 1944 to film the sequel to *My Friend Flicka*. Roddy McDowell, age 15, was in the movie *Thunderhead, Son of Flicka*, and locals were hired to fill the stands.

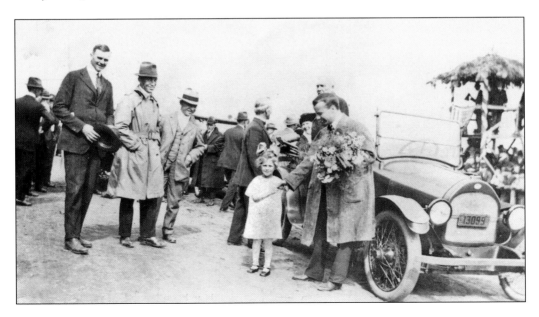

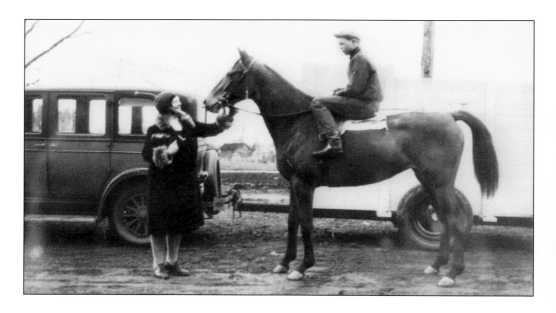

As the fair grew in size and length, a racetrack was added for both harness and horse racing. The jockey in the photograph, Jimmy Moore, on the horse Tar Box, is being given encouragement and admiration by his mother. Automobile racing was added, and one of the most featured events was the Ford Model T and pig race. This crazy event brought howls of laughter from the crowd. Only Model Ts were allowed—no matter how old, as long as they ran—and drivers had to carry a pig with them.

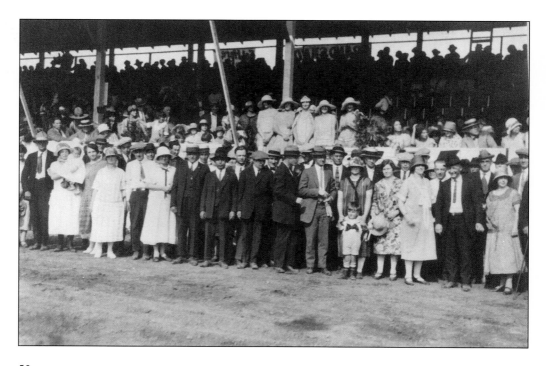

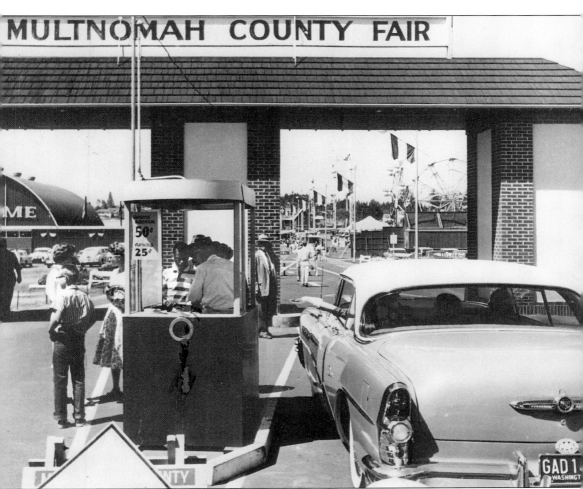

It did not cost much to enter the Multnomah County Fair in the 1950s. For 50¢, a person had access to free horse racing every night, two stage shows per day, entry into all exhibits and contests, plus an assortment of games with prizes. Entrance was easy up until the time a fence was built around the fair with the five arches as the main entrance. Of course, when the guards were not looking, if someone were quick, he could sneak in over the fence. If caught, trespassers were thrown out, but if successful, they had extra coins to spend inside. (Photograph courtesy Oregon Historical Society; OrHi Negative #68013.)

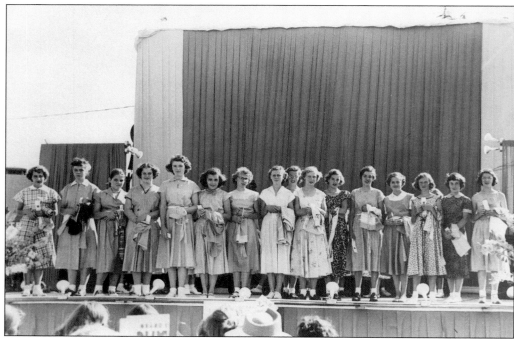

Sewing was just one of the categories in the 4-H entries at the fair. Others included cooking, canning, and domestic and gardening skills. There was practical use for the people who entered their talents and products. What was learned could be put to good use in the home and on the farm. The c. 1950 photograph above shows the recipients of the sewing awards. Two other very important categories were canning and baking. On the canning shelves (below), fairgoers could find anything in the way of fruits and vegetables. Often, for a small price, small samples of the luscious bakery goods could be purchased. It was a part of the fair no one wanted to miss.

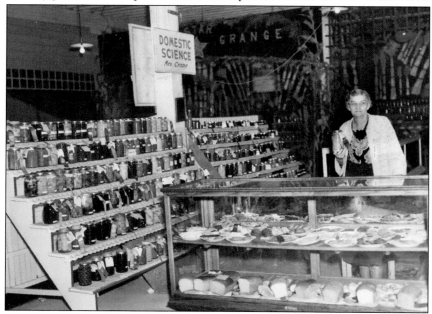

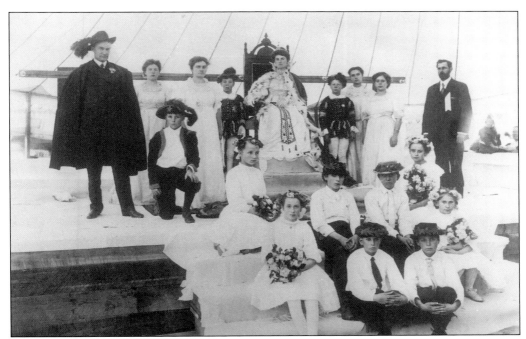

A fair often has a queen, and the first fair was no exception, as Queen Lucy Metzger reigned over these festivities. Shown in the photograph are, from left to right, (on the front steps) Evelyn Metzger, Isabell Metzger, Floyd Metzger, Ray Palmquist, Harry Mason, Harvey Rainey, Pearl Hamlin, and Nellie Farris; (on the stage) Frank Motter, Elsie Crenshaw, Charlie Turner (kneeling), Florence Stafford, Wallace Wilkinson, Queen Lucy (on the throne), Chester Daily, Jennie Metzger, unidentified, and J. J. Johnson.

Rodeos also came to Gresham and attracted many visitors. Shown in a photograph of the July 1, 1948, rodeo are Wally Green of the Gresham street department (left) and Carl Zimmerman (right), owner of Zimmerman's 12 Mile Store. The person in the booth is unidentified.

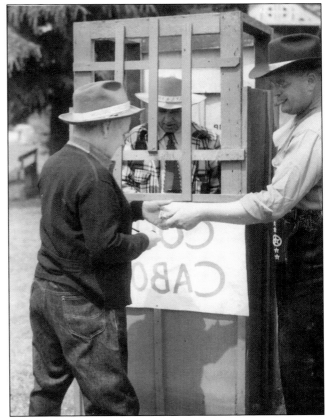

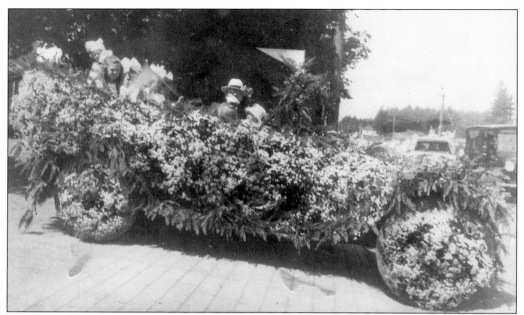

Gresham's Fourth of July parades featured decorated automobiles and booths where drinks and food could be purchased. In 1911, in addition to the parade, the day's featured attractions included music, a ball game, dancing, a picnic in the grove, and races on the new track at the fairgrounds, with events ending with a grand ball in Metzger's Hall at night. Shown in the automobile at the July parade are Karl A. Miller, the driver, and with him in the front seat are Virginia ? and Jean Elkington. In the back of the automobile is Margaret St. Clair; the others are unidentified. Below, ready to serve thirsty or hungry patrons are, from left to right, Velma Metzger, Walter Metzger, and Russell Pugh.

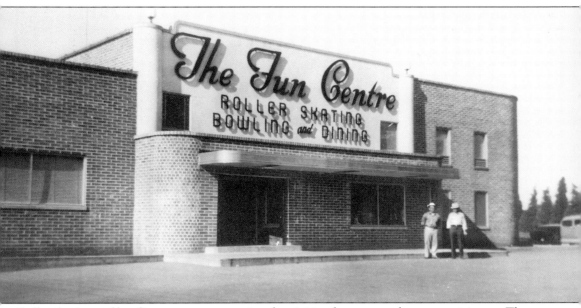

Roller-skating and bowling were two recreational activities that attracted many participants. The Fun Centre was located at Powell Boulevard and Elliot Street and was a popular place in the 1940s and 1950s. Pool and snooker tables and the bowling lanes were located downstairs, and young people were employed as pinsetters. Upstairs was the roller-skating rink.

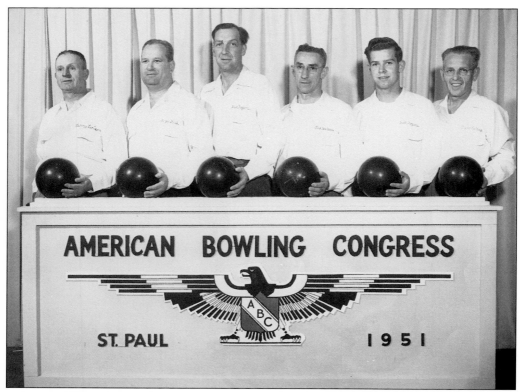

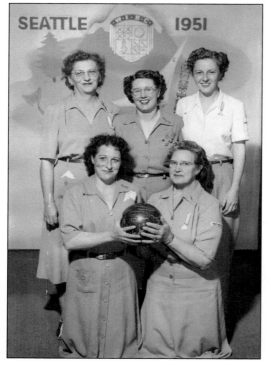

Area bowlers were often good enough to participate in tournaments across the nation. This team includes, from left to right, Larry Larison, Fergie Risk, Rod Rodgers, Ted Mullan, Billy Rodgers, and Glen Collins. They traveled to St. Paul, Minnesota, for a 1951 event.

Women were not excluded from competition outside the local area. This team is composed of, from left to right, (first row) Ruth Robinson and Agnes Hartwig; (second row) Luella Anderson, Mayme Risk, and Emily Mullan. Their tournament was in Seattle, Washington, in 1951.

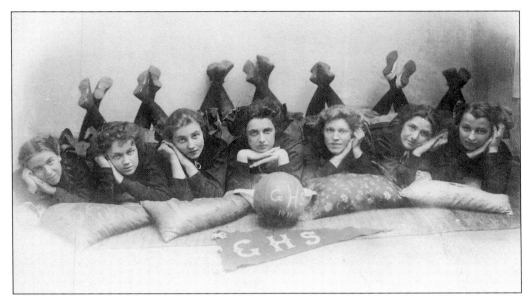

As schools were established, sporting events became popular among those attending. Basketball was one of those sports, and several girls' teams came into existence. These two c. 1910 photographs show the Gresham High School girls' teams. The picture of the girls above includes, from left to right, Olive Mennel, Lottie Davis, Marguerite Michel, Maude Michel, Margaret Schantin, Ethel Wilkinson, and Evelyn Metzger. The only identified girl in the photograph at right is Evelyn Metzger, on the left in the first row.

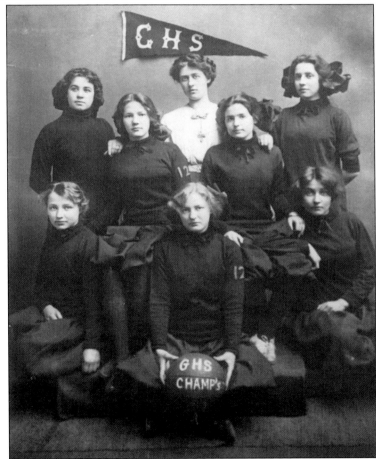

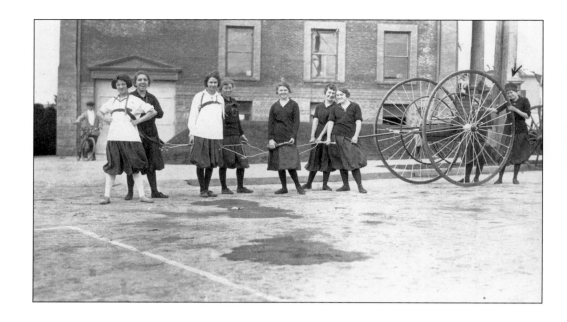

Hose teams were started in the early 1900s merely as a means of entertainment. The girls, who were given the title of Volunteer Women's Fire Hose Team, would travel throughout the area and compete with hose teams from other cities. The object was to see which team could travel to a "fire" and unroll a hose in the least amount of time. The Gresham team would go as far away as Astoria. The above photograph was likely taken in Astoria, and the one below was in front of the old city hall.

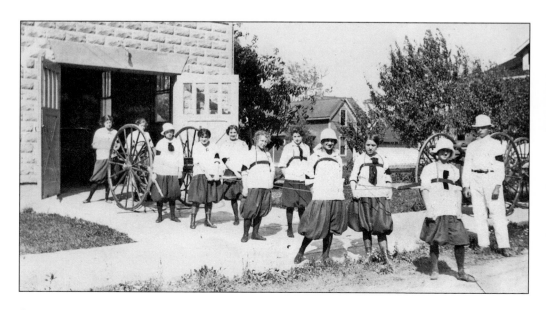

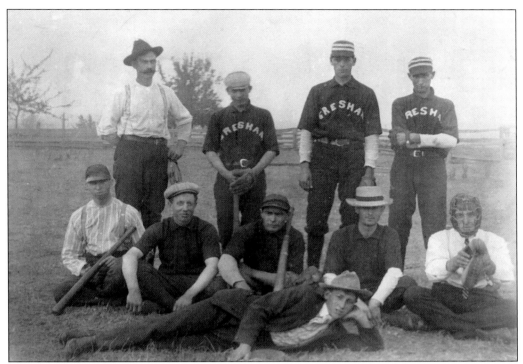

America's number one sport around 1900 was most certainly baseball, and each small town developed its own team. Often there were just enough players to field a team, as the photographs indicate, with one member serving as coach. Equipment was crude in the early days. The photograph taken in front of a grove of trees shows Charles Lundberg in the first row, far right, and the others are unidentified.

By the 1930s, the number of players on a team had increased, and a batboy had been added to the team, as well.

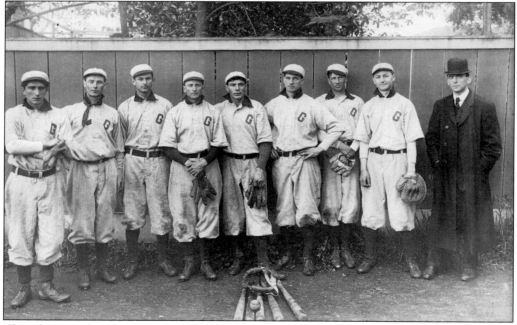

This photograph, taken around 1912, shows eight players and a manager. The team had nine players and one is missing from the photograph. The players' names are Leslie Merrill, Charlie Merrill, Bert Metzger, Bill Senuck, Charles Larsen, Carl Wetts, Fritz Wetts, Tom Townsend, Bill Hamilton, and V. Pateneaude (manager).

Five

ORGANIZATIONS AND CHURCHES

Organizations serve as a means for local citizens to get together. Over the years, the Elks, Odd Fellows, and other clubs developed and grew in the area. Bands were formed that played at local celebrations. And Sunday was the day for religious observances.

The very first church services were held in settlers' homes. The area known as the Camp Ground was owned by the Methodist Church, and each Sunday it would be overflowing with horse teams, wagons, and buggies. After the 1880 windstorm blew down most of the trees in the campground, the Methodists built a small church on the site. The congregation shared a pastor with other towns in the area.

The first Baptist church came into existence in 1884. Henry and Clementine Metzger provided land for the sum of $1. With some financial help, a church was built on the southeast corner of Walters Road and Powell Boulevard. It was called the Powell's Valley Baptist Church. Soon other denominations were formed and built their own places of worship. In 1886, the Catholics built a church, known as the Kronenberg Mission Church. St. Henry's was built in 1913 and has expanded greatly over the years.

The Lutherans, meeting in the home of the Salquist family in January 1899, organized Saron Lutheran Church. The building was dedicated in December 1900. It was 24 feet by 36 feet with an 8-foot-by-8-foot tower. Other Lutheran churches and more denominations followed. This chapter touches on some of the faiths and happenings within the local churches and a few organizations.

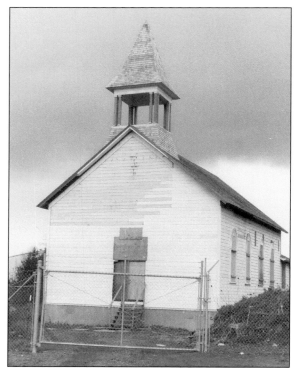

The congregation of the First Baptist Church initially met in the "white school house" in the late 1880s while a permanent church was being built. Financial assistance was received from Johnson Cleveland and James Stott, and Peter Engles was the builder. The German Baptists were a part of the church, but agreed in 1906 to accept $250 for their interests. Thus, the Bethel Baptists became owners of the church and the sole denomination. The church stood for many years and was finally moved to Main City Park in 1979. The original building that served for a long time as both a school and church was finally destroyed by vandalism and fire.

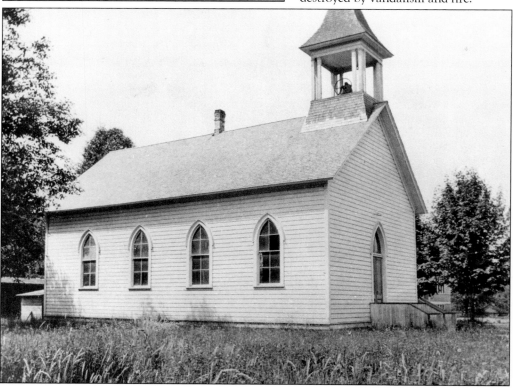

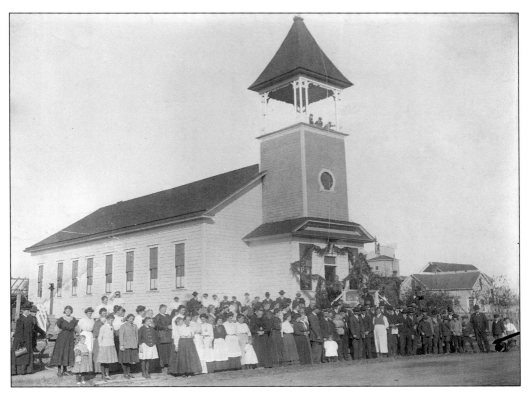

Granges were popular with early settlers, much as some still are today. The Rockwood Grange first started meeting around 1900 and gathered at Bell Store about 1905. Land was purchased around 1907 and a building constructed thereafter. The Rockwood Grange had a large contingent for its dedication in 1912. By 1915, the open area near the top of the tower was closed off for unknown reasons.

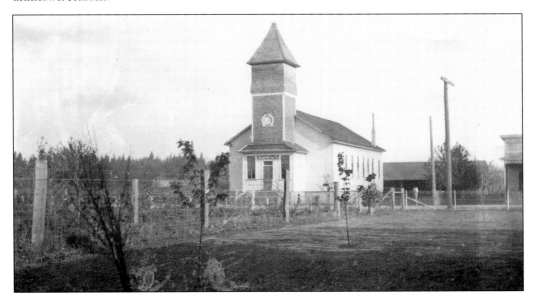

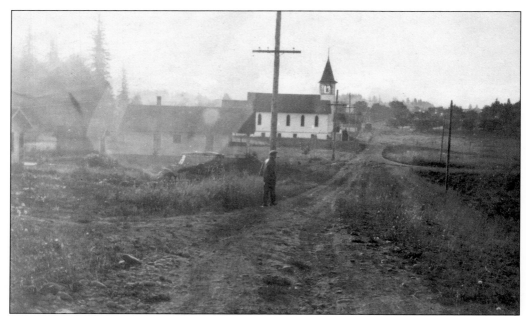

As with many denominations, Catholic services were first started in the Gresham area in people's homes. The second Catholic church east of the Willamette River was built near 162nd Avenue and Powell Boulevard, approximately where the Meadowland Dairy is located. In 1886, it was the closest Catholic church to Gresham. The congregation moved from that location to 182nd Avenue and Yamhill Street, where the church was renamed St. Anne. St. Henry's Church, seen in the two photographs, was completed in the fall of 1913 and was located near its present site at First and Ava Streets.

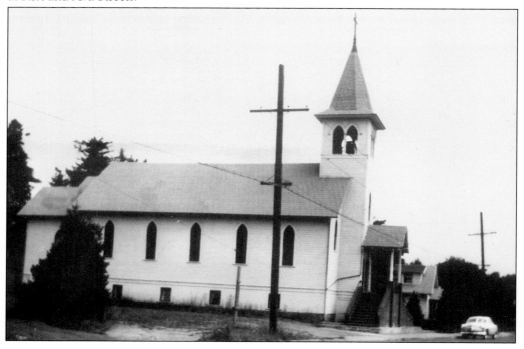

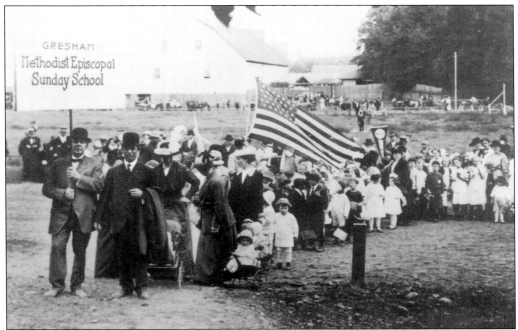

The area mentioned earlier as Camp Ground was owned by the Methodist Church, and services were held there. A permanent small church was constructed on 2 acres in the southeast corner of the lot. A new church was constructed and dedicated in 1907. It was built by Jake Metzger, and a $2,000 pipe organ was installed in the main chapel. The church became known as the Linnemann Memorial Methodist Episcopal Church after a donation of $500 by "Gramma" Linnemann in memory of her husband. The Gresham Episcopal Sunday School is shown performing at the Multnomah County Fair. As with most churches, outings outside the community were popular as this visit to one of the falls, probably in the Columbia River Gorge, shows.

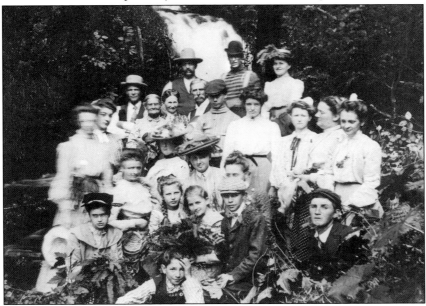

A large class attended this vacation bible school, above. Shown below is the Philathea Class of the Taylor Street Church. The majority of the people are unidentified. A Mrs. Saylor is listed as the teacher.

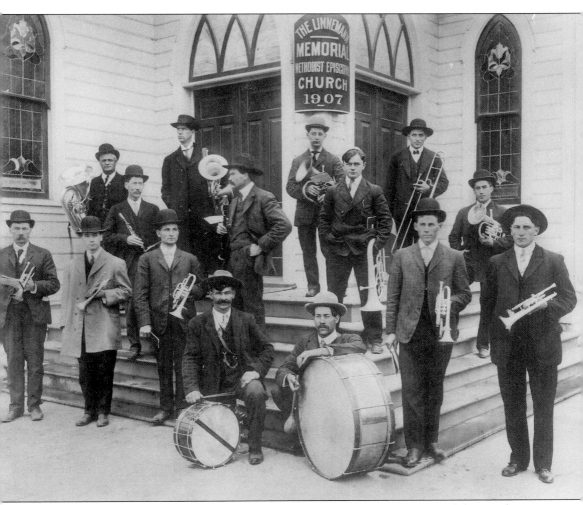

The steps of the Linnemann Memorial Methodist Church were the site of one of the Gresham Band's performances. Band members are, from left to right, (first row) O. I. Neal, unidentified, Fred Fieldhouse, Harvey Metzger, two unidentified, and Charlie Merrill; (second row) Alfred Stout, Guy Robertson, Guy Fieldhouse, and Dan Talbot; (third row) Arthur Fieldhouse, Harry Ott, Dr. Bittner, and Wells or Vern Chalker. The band was a popular attraction.

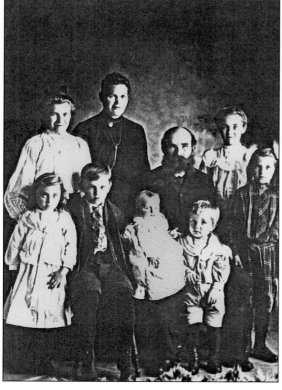

It was not long before members of the Lutheran faith who moved into the area decided it was time to form a formal congregation. Like other faiths, they first met for services in homes. Swedish immigrants were responsible for creation of the congregation, and the home of Peter Salquist, shown in the sketch, served as a church on many occasions. Since there was no official pastor, visiting clergy from the area served the persons assembled. A small church was started in late December 1899, and a year later it was completed. Each member had been assessed $25 to build the 24-foot-by-36-foot structure. Services were initially held in Swedish, but it was not long before English was used every other Sunday. In 1938, Swedish was dropped, and additional services were held in German. (Photograph and sketch courtesy Trinity Lutheran Church.)

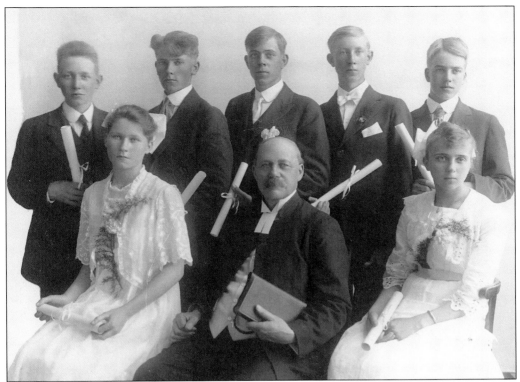

Confirmation classes are an important part of Lutheran teaching. Members of this 1917 class are, from left to right, (first row) Emma Johnson, Pastor Benson, and Mabel Staffenson; (second row) Arvid Peterson, Carl Johnson, Ernest Anderson, Ruben Staffenson, and Archie Anderson. The congregation is shown outside the small church in 1930–1931 before a new church was constructed at Ava Street and Powell Boulevard in 1933. The building was started in 1932 in the midst of the Great Depression. A few of the people in the photograph have been identified, and the names are available at Trinity Lutheran Church. (Photograph courtesy Trinity Lutheran Church.)

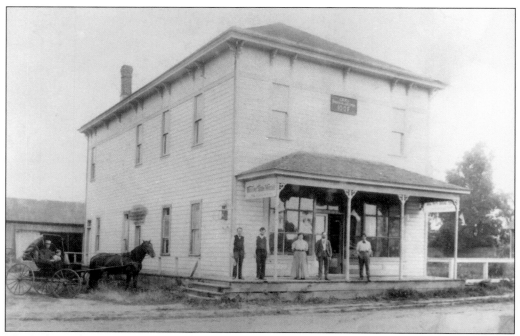

The Independent Order of Odd Fellows (IOOF) was one of the organizations that grew in the Gresham area. The lodges often contained prominent members of the community. They usually met in a building that was their own, and the Gresham lodge met on Saturday evenings. The organization is still in existence in many towns throughout the nation today. Shown in the photograph inside their meeting hall in the early 1900s are, from left to right, (first row) unidentified, George Kenney, and unidentified; (second row) ? Johnson, unidentified, Jacob Metzger, Martin Roberts, George Preston, and John Roberts; (third row) John Sleret, Bryon Emery, unidentified, Lewis Shattuck, unidentified, Roy Gibbs, unidentified, and Ed Sleret.

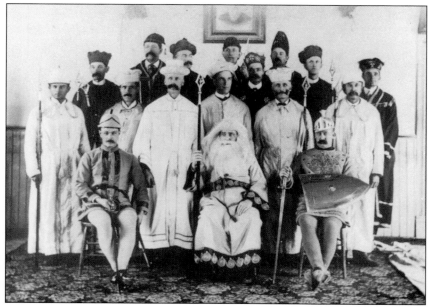

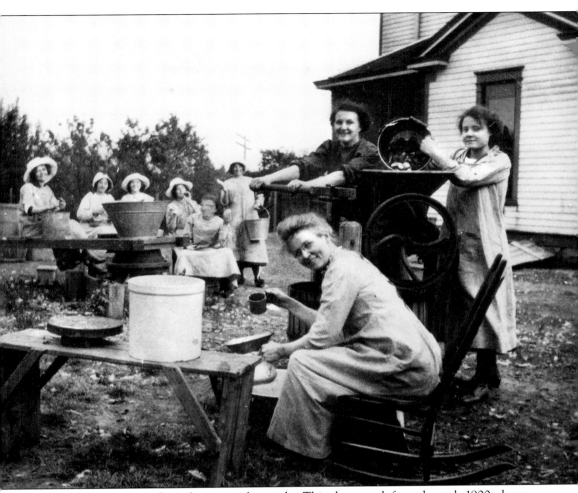

One of the fall duties for early settlers was making cider. This photograph from the early 1900s shows a group of women and their children peeling, squeezing, and then tasting the delightful liquid.

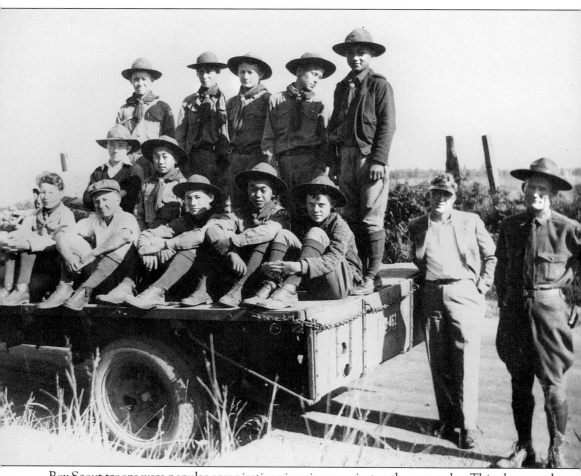

Boy Scout troops were popular organizations in prior years just as they are today. This photograph shows Boy Scout Troop No. 273 sponsored by the Cedar School PTA. Pictured are, from left to right, (first row) Homer Townsend, Arno Schindler, Bob Townsend, Nogi Asakawa, and Ernie Speybrock; (second row) Leland Carter and Jack Asakawa; (third row) Laverne Gould, Russel Gould, Harold Townsend, Vernon Townsend, and Sueki Murahata. Standing on the ground are Dr. Thomas B. Carter (left) and scoutmaster Eddie P. Townsend.

Six

THE TOWN

As more settlers moved into the Powell Valley area, entrepreneurship developed. First there was a grocery store so settlers would not have to travel to distant Portland to acquire their products. Soon other businesses were born, such as a bakery, livery stable, blacksmith, drugstores, hotels, more grocery stores, and others.

Shortly after the invasion of Henry Ford's automobile, dealerships of that car and other makes became established. Garages, where a car could be repaired, were opened mostly by local citizens. This led to the slow demise of blacksmiths and livery stables. In 1905, Gresham's first bank was established. Soon hotels that could accommodate several guests and stores that sold all sorts of equipment and goods moved into the area or were developed by local citizens. Dentists and doctors established practices. Long before Gresham was incorporated, Dr. John Parker Powell served the health care needs of local citizens. Traveling by horseback, he made home calls on patients, a practice that has long been forgotten. The electric transit system brought many visitors into the area. Thus there was a strong need for additional stores. From the earliest days, the Metzgers and Shattucks were actively involved in the city's business community.

As towns grow, they also need services such as fire and police departments. The disastrous blazes mentioned earlier led to the formation of a volunteer fire department in 1910. Volunteer firefighters still serve the city in some capacity, but the main responsibility lies with the Gresham Fire Department. In early years, a town marshal or constable was hired to enforce the ordinances passed by the city. As the population grew, however, an official police force was needed, and in the 1930s it consisted of three officers.

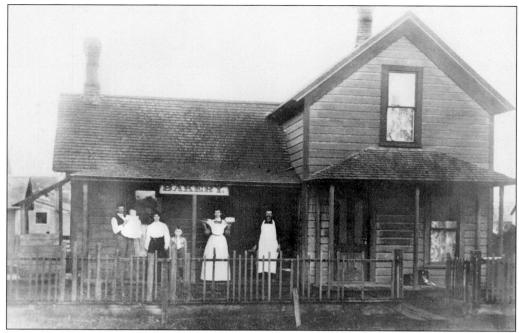

The Johnsons are credited with developing the first bakery in Gresham in 1892. Mrs. Johnson is shown proudly displaying two of her cakes in the photograph.

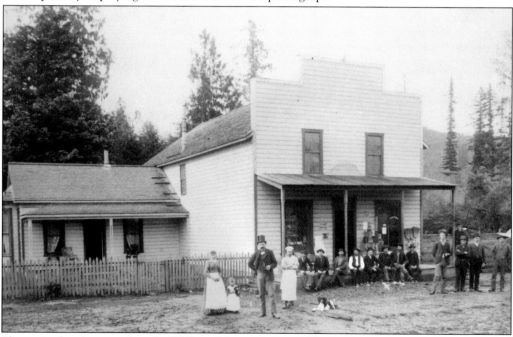

Shown in the photograph is the William Johnson store and home. It was located on the southwest corner of Powell Boulevard and the Fairview-Damascus Road (Main Avenue). Johnson is the gentleman in front with the stovepipe hat. Several members of the Metzger family are also present, as well as a Shattuck and Kenney.

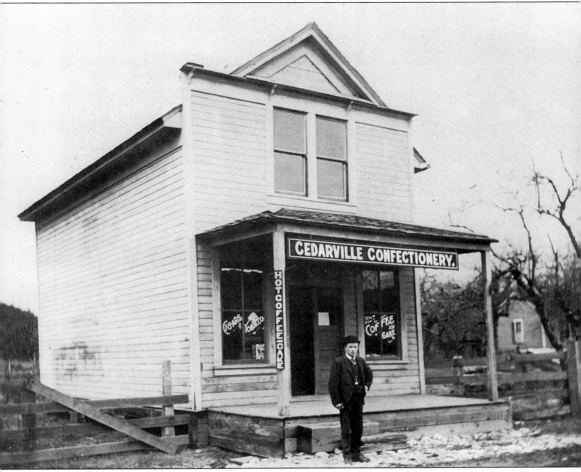

In an area to the west and slightly south of Gresham, the community of Cedarville was established in the late 1890s. A few houses were built nearby, but although the location was platted, an actual town never developed. There was, however, the Cedarville Confectionery. Richard Forbes is shown in front of the store that was located near 188th Avenue and Powell Boulevard in the early 1900s. The early trail that led people to Portland passed through the area much as Powell Boulevard does today. On August 15, 1911, the *Gresham Outlook* reported, "Cedarville Grocery doing quite a bit of business."

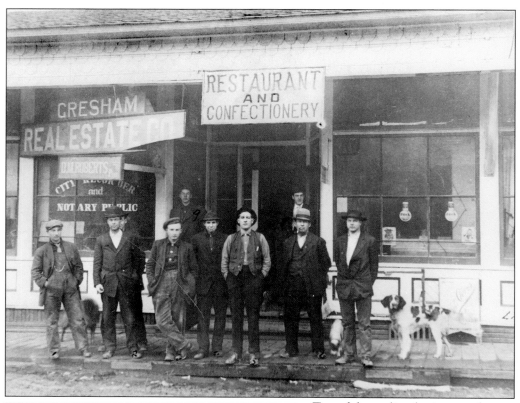

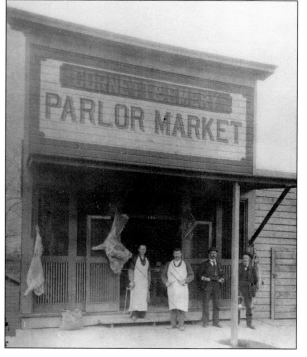

Two of the earliest businesses along Main Avenue were a restaurant and confectionery and the Cornett B. Emery Parlor Market. Adjacent to the confectionery was a real estate office with D. M. Roberts listed as the proprietor. The confectionery was located near Main Avenue and Powell Boulevard, and Bryon Emery's meat market was near the corner of Powell Boulevard and what would be named Roberts Street. Emery also had a meat delivery wagon. The pictures were taken around 1908.

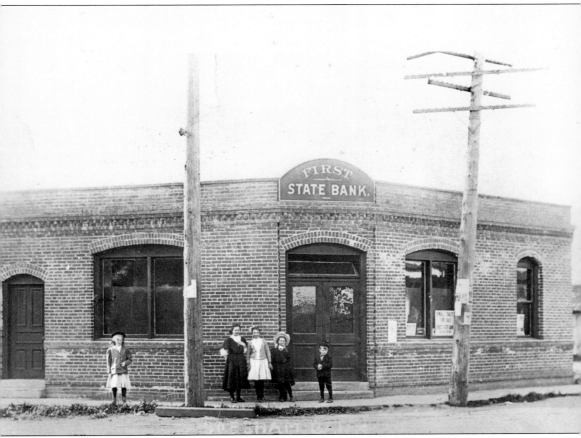

With the area growing, a bank was needed. The First State Bank opened a branch in Gresham in 1905. It was located at the corner of Powell Boulevard and Main Avenue. Archie Meyers served as president; Theodore Brugger was vice president, and Carl Lundquist was cashier. Three of the individuals shown in front of the bank about 1908 are Ruby Emery Buckles, Lena Wright, and Ted Wright; the rest are unidentified. In a statement in the *Gresham Outlook* on September 20, 1916, the bank listed deposits of $192,876.11 as compared to $29,558.44 on September 20, 1906.

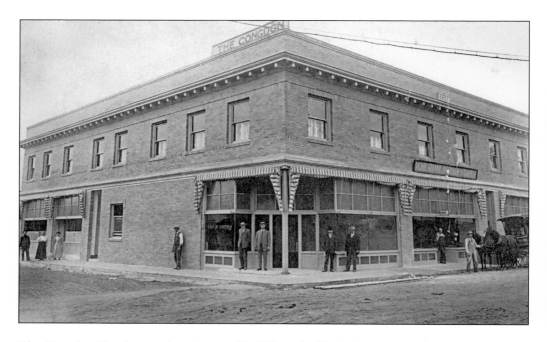

The Congdon Hotel opened on August 12, 1911, and offered American and European plans. It was located on the northwest corner of Main Avenue and First Street. At the time, it was the premier place for people to stay overnight in the Gresham area. It also contained a restaurant with advertised meals at 35¢ and a special Sunday chicken dinner for 50¢. Clara Hill is shown in the photograph below with an unidentified customer. When it opened, the hotel was advertised as "absolutely fire-proof." It sustained only slight damage in the disastrous fire of December 1914.

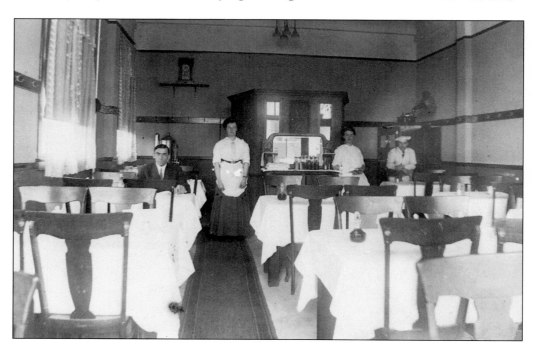

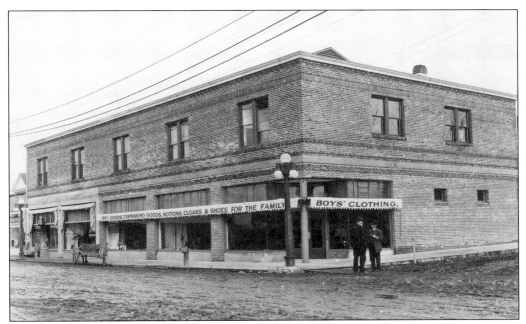

The roads had not yet been paved in this photograph of the W. R. Hicks Store, a clothing emporium located on the northeast corner of Main Avenue and Second Street. The second floor was used as a meeting place for the Masons until Hicks expanded the store upstairs. Hicks initially had several partners, but he assumed sole ownership of the store in 1926. He was noted for treating his employees fairly and equitably. In 1958, a new building was constructed just east of the old one.

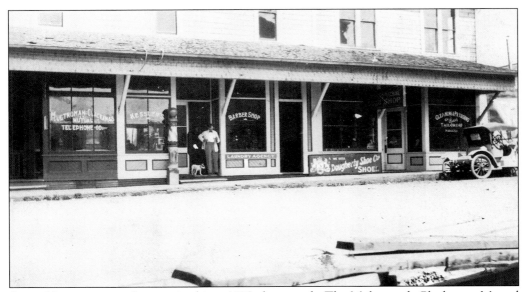

Several businesses can be seen in this c. 1920 photograph. The Multnomah Clackamas Mutual Telephone Company is on the left, and Kessler's Barber Shop sits next to it. A doorway leads to offices upstairs on the second floor. To the right of the doorway is the Carl Dahl Shoe Shop and next to it the business of Peter Lenard, a tailor. The building is likely on the northeast corner of Main Avenue and Powell Boulevard.

The Ford Truck *vs.* Horses

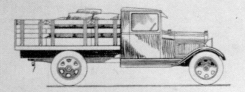

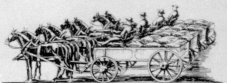

Price—(F.O.B. Detroit) 1½ Ton Chassis, Stake Body, and Closed Cab . . **$675**

Price—8 Horses and 4 Wagons **$1200**

Truck Operating Costs Per Mile

Gasoline—11 mi. per gal., 22c gal. . . $.02
Oil—5 qts. per 500 mi., 20c qt.	.002
Lubrication—50c per 500 mi.	.001
Depreciation—⅕ of cost less tires per year*	.052
Tire allowance*	.009
Repairs	.008
Interest—6% of third year value†	.009
Insurance at 5% of value	.016
License—$24.00 per year	.011
Total cost per mile . . . $.128
Total per year (2111 miles) . . . $270.21	

Cost of Keeping Horses Per Horse

Feed	$ 133.64
Shoeing	2.16
Veterinary	1.13
Chores	15.83
Interest Horse and ½ Wagon)	9.00
Harness	4.82
Depreciation (Horse and ½ Wagon)	10.00
Total	176.58
Manure Credit	15.00
Total Net Cost per head	161.58
Total Net Cost eight horses per year	$1292.64

Based on several hundred cost reports on the 1½-ton Ford Truck and on United States Department of Agriculture Bulletin No. 1314—"Motor Trucks on Corn Belt Farms."

*Cost of tires written off per mile.
†Average of 5 years' life.

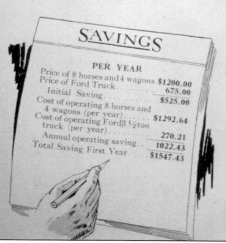

SAVINGS
PER YEAR

Price of 8 horses and 4 wagons	$1200.00
Price of Ford Truck	675.00
Initial Saving	$525.00
Cost of operating 8 horses and 4 wagons (per year)	$1292.64
Cost of operating Ford 1½ ton truck (per year)	270.21
Annual operating saving	1022.43
Total Saving First Year	$1547.43

Based on United States Department of Agriculture Bulletin No. 997, "The Cost and Utilization of Power on Farms Where Tractors Are Owned" and "Bulletin No. 931," Comparison of Time Required to Haul with Motor Trucks." This shows that a 1½-ton truck replaces 8 horses.

What could very well be an advertisement for Ford trucks compares owning eight horses and four wagons to a "1.5 Ton Chassis, Stake Body, Closed Cab" Ford truck. The comparison, however, was based on U.S. Department of Agriculture Bulletin No. 997.

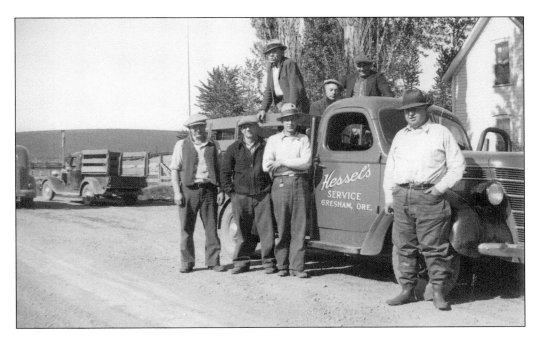

The Hessel family had a long business history in Gresham. J. C. Hessel opened a farm machinery shop in Gresham in 1908 similar to the one he had owned in Minnesota. In the August 29, 1916, edition of the *Gresham Outlook,* he advertised an Anker Holth Cream Separator as one of the farm implements available. However, it did not take Hessel long to enter the automobile dealership selling Willys Overland cars. That led to a repair service. Standing in the truck are Ray Metzger (left), Jim Chisum (center), and Frank Welty. Those alongside the truck are, from left to right, John Wetenkamp, Arthur Keropsky, George Moen, and Ralph Deaville.

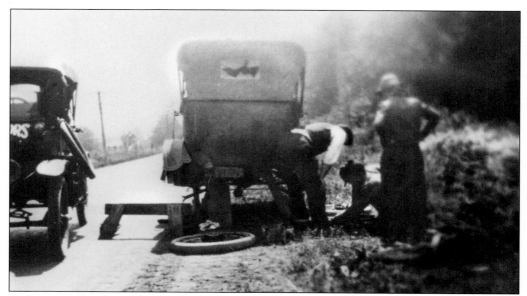

Today we call it AAA, but little do folks know that many years ago there was a "car doctor." Clifton Harris was a traveling mechanic, assisting motorists—in this case, a couple that needed service for their automobile.

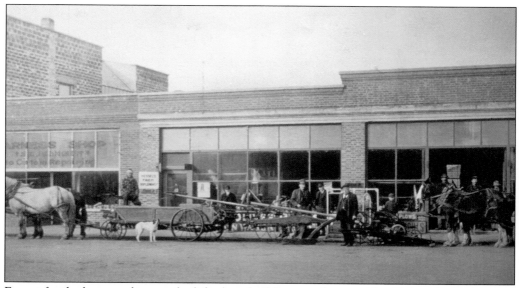

Except for the harness shop on the left, these buildings on the east side of Main Avenue around 1900 appear to have been vacant. They were later occupied by Hessel Farm Machinery.

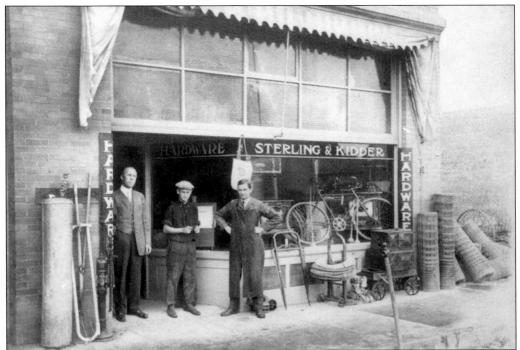

In 1911, Sterling and Kidder was one of the prominent hardware stores in Gresham. It had been originally called Sterling and Johnson. As the photographs show, in addition to hardware, there was a bicycle repair shop in the rear. In an advertisement in the *Gresham Outlook* on August 29, 1916, Sterling and Kidder Hardware Company lists a Blue Bird bicycle for $27.50. The people standing in front of the store are from left to right, Louis Kidder, Glen Miller, and Karl Miller. The two people inside the store (below) are likely Glen Miller (left) and Karl Miller.

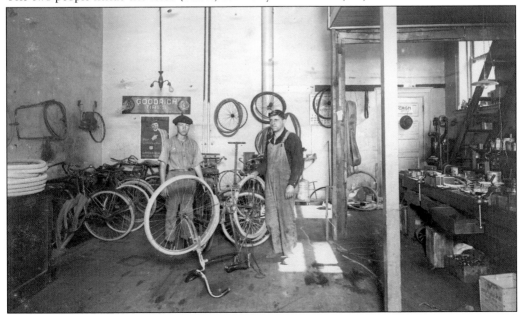

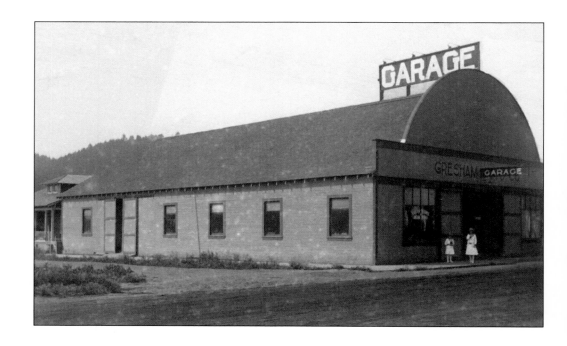

With the coming of the automobile, garages and repair shops opened at several locations around Gresham. The *c.* 1911 photograph (above) shows the garage built on southeast Powell Boulevard and Roberts Street. The *c.* 1922 photograph (below) shows the Tilgner Main Street Garage on Main Avenue. Main Avenue is often erroneously referred to as "Street," and it is possible this was also the case in 1922. One automobile shop advertised, "Autos For Hire" in the *Gresham Outlook* as early as 1911.

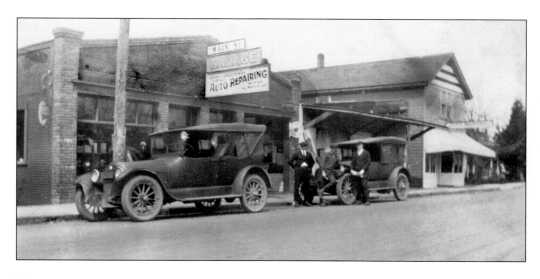

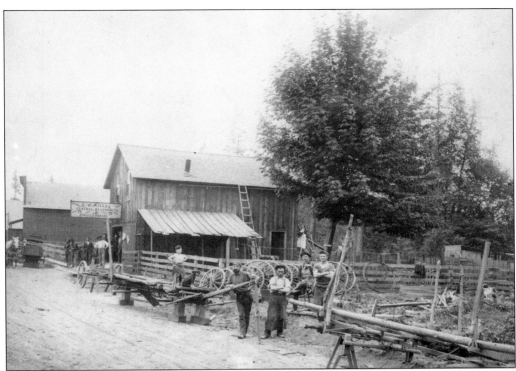

Prior to and around 1900, two of the more important businesses in Gresham were livery stables and blacksmith shops. The photograph above, taken around 1892, shows the C. C. Miller Blacksmith Shop located on the south side of Powell Boulevard near where the Masonic Temple is now. The sign also advertises horseshoeing. The livery and feed stable is that of B. W. Emery, located on Powell Boulevard and Roberts Street. He also is listed as having the first hearse service in the area. He is also credited with delivering meat to logging camps with teams of horses and wagons.

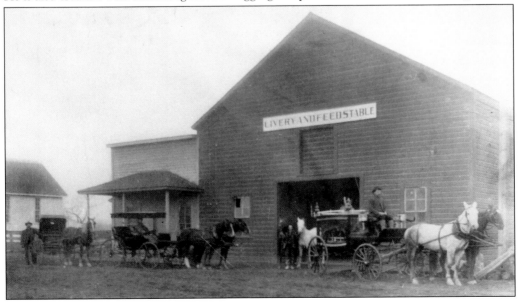

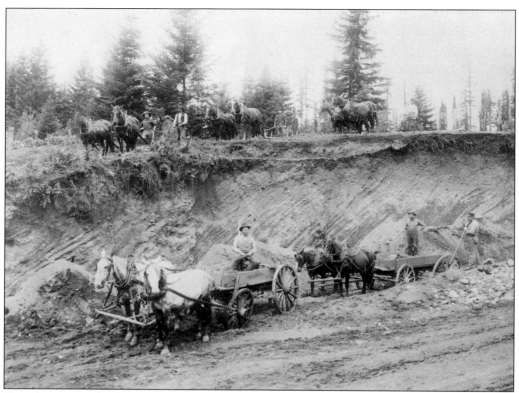

Gravel pits were developed to haul gravel to construct the area's roads. In the above photograph, Bob Wright is in the foreground at the Gresham gravel pit located on Fairview Avenue and Farris Road. The c. 1890 photograph below was taken at the Linnemann Gravel Pit. Some of those identified in the photograph are Dave Weaver, Ed Sleret, Arnie Ruegg, Allen Shattuck, and Schuyler Jones.

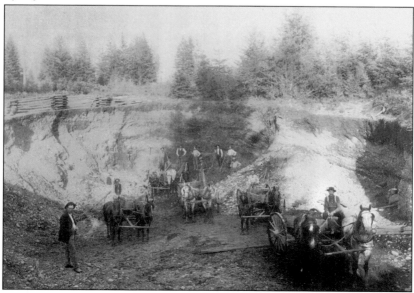

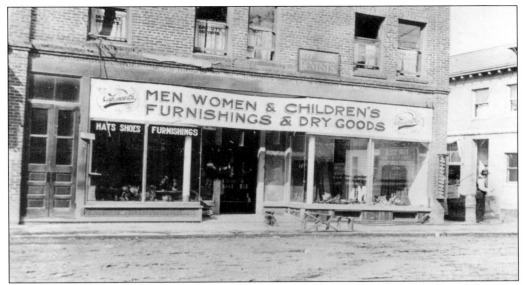

The Aylsworth store sold men's, women's, and children's furnishings, as well as dry goods at the southwest corner of Main Avenue and First Street. Doctor and dentist offices were often located on the second floor of buildings in downtown Gresham.

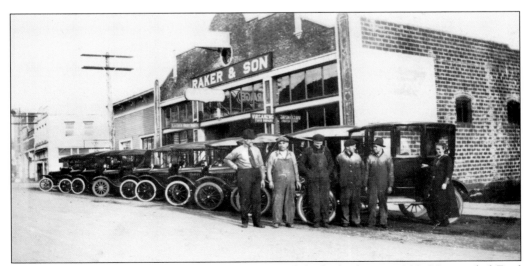

Charles Lautourell opened the town's first automobile dealership in 1908. He retailed Ford automobiles, and in 1917 sold the business to Raker and Son. The enterprise was located on the south side of Powell Boulevard just west of Main Avenue. The photograph is looking east along Powell in the mid-1920s.

An abundance of potatoes was harvested in the Gresham area. The *Gresham Outlook* in its Tuesday, May 13, 1919, edition reported, "Among the new industries of Gresham and vicinity may be mentioned the co-operative starch factory." The newspaper goes on to say that a J. F. Griffith found an ideal building on South Roberts suited for the purpose. It was the old cheese factory. Griffith was remodeling the building and had plans to convert it into a six-story structure that also included dehydration facilities. The article mentions that it was only the second starch factory in the state, making use of culled potatoes that had been lost to the growers. The cheese factory had only been in existence a few years.

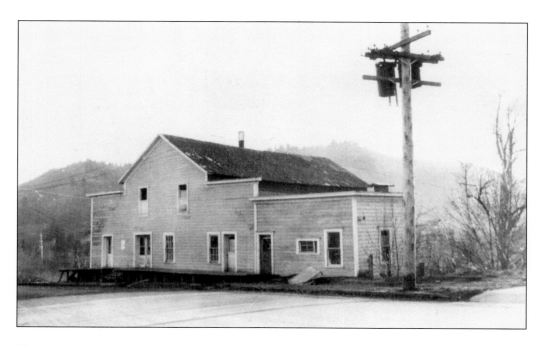

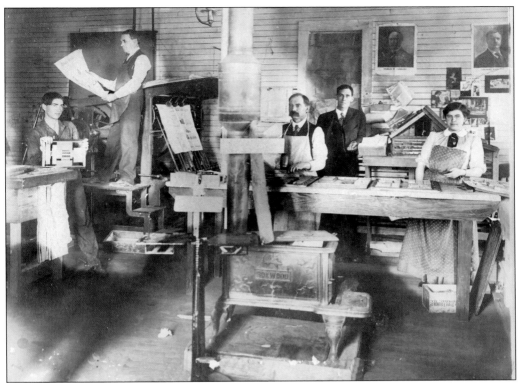

The history of newspapers in the area goes back to before 1900. There were several attempts to make a Gresham newspaper a successful operation. Ford Metzger was credited with publishing the first local paper prior to 1900, but the name Gresham did not appear on the header. Other attempts after that included the *Gazette* and the *East Multnomah Record*. The above photograph is that of the *Beaver State Herald* office in 1907, and the below one is the *East Multnomah Record* around 1904. The *Beaver State Herald* moved its entire operation to the Lents area in 1911.

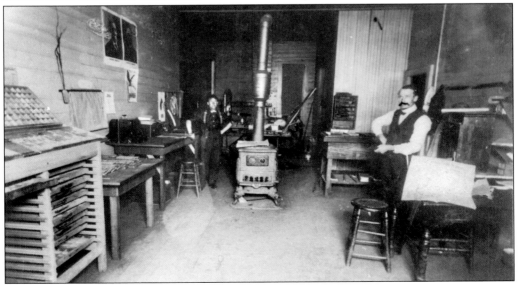

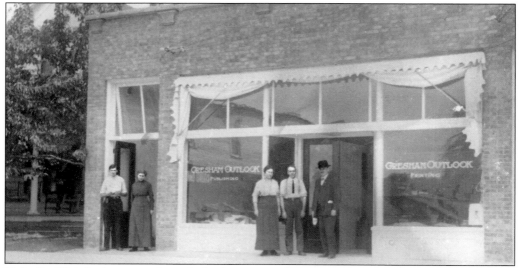

H. L. St. Clair had more to do with the formation of a permanent newspaper in Gresham than any other individual. He had worked for others in the newspaper business, but in 1911 founded the *Gresham Outlook*. The newspaper was a family operation. Son Chase was editor, and H. L.'s wife, Lena, was bookkeeper, proofreader, wrote stories, and kept track of the paper's finances. Shown outside the newspaper on Main Avenue are, from left to right, Chase St. Clair, Emma Johnson, Lena St. Clair, H. L. St. Clair, and an unidentified customer.

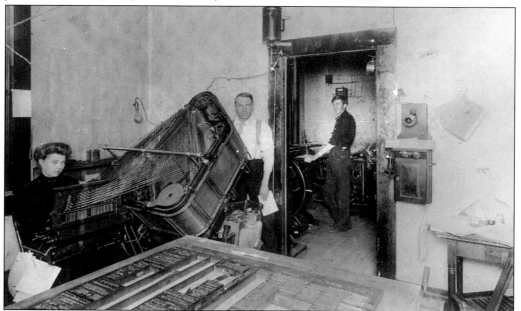

St. Clair put heart and soul into the production of the paper. He acquired a new Linotype machine normally found only in larger cities but rarely in a town the size of Gresham, and his paper had two editions per week. The lady in the photograph is Emma Johnson, who operated the Linotype. She worked for the newspaper for 30 years. H. L. St. Clair is shown standing by the machine. His son, working as a "devils printer," was responsible for setting the type upside down and backwards. The office also had one of the first telephones in the Gresham area.

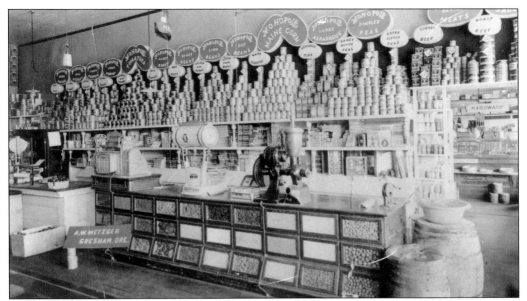

In 1918, A. W. Metzger owned a state-of-the-art store on the southwest corner of Roberts Street and Powell Boulevard. It held a large number of canned goods and barrels with other popular products. Metzger even provided lunches. An ad in the *Gresham Outlook* on August 29, 1916, indicated: "Why bother with cooking these warm days? Ask us about lunch goods." Sandwiches cost 15¢ to 25¢, and an assortment of fruits and vegetables were available as well.

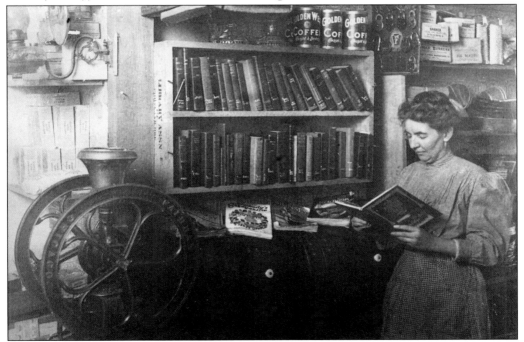

Even before those first residents officially recognized the need for a library, a makeshift one existed in a backroom of the Powell Valley Store in east Gresham. The library books are sharing shelf space with store goods and a coffee grinder.

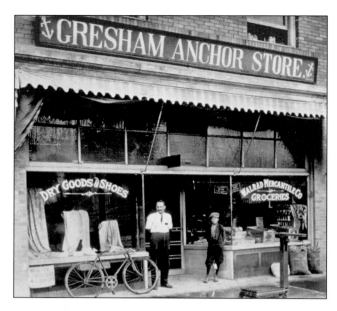

Located on the west side of Main Avenue, north of the Congdon Hotel, Gresham Anchor Store was in business in the early 1900s. Listed as the Walrad Mercantile Company, it sold dry goods, shoes, groceries—almost anything. A March 7, 1911, ad in the *Gresham Outlook* advertised, "We Have the Goods to Suit You," and a June 9, 1911 spot in the paper announced, "Last Forever Stockings, 25¢." Pictured are Burton Walrad Sr. (left) and Burton Walrad Jr. The store originally was the Walred Mercantile Company and later became the Gresham Anchor Store, which is no longer in existence.

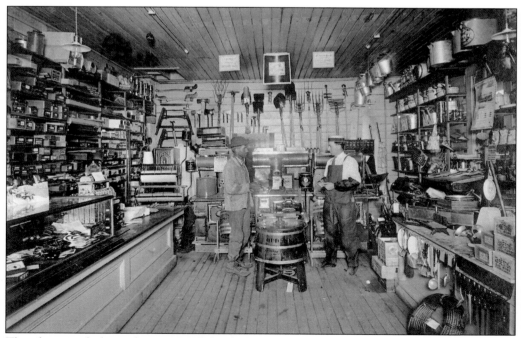

This photograph shows the interior of the Sterling and Johnson Hardware store. Johnson is shown with an unidentified customer. There are a wide assortment of goods on the shelves and farm implements hanging from the walls.

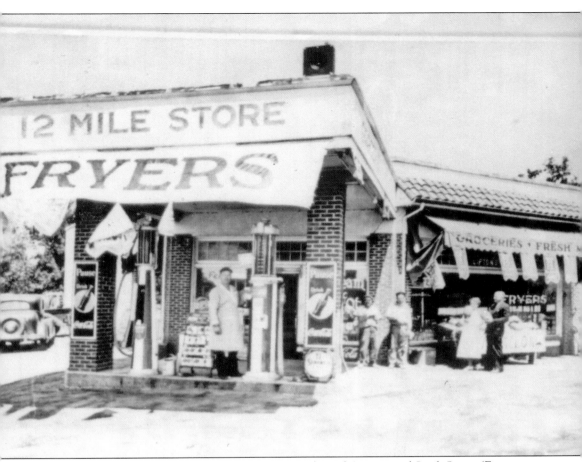

The 12 Mile Store was located on the northeast corner of 223rd Avenue and Stark Street (Fairview Road and Baseline Road in the early 1900s). Carl Zimmerman leased the building in 1938 from Ed Alysworth and developed it into a landmark in the Gresham area. The store sold an assortment of items from groceries to home items. By many, it was considered the first supermarket in the area. Prior to that, however, a roadhouse was located on the southeast corner of the same intersection. During the Roaring Twenties, it was a major nightspot in the Gresham area. Fred T. Merrill operated the establishment, complete with racing track just south of the building. Markers at every mile on Stark Street led the way to the 12 Mile house.

The automobile changed America's landscape and therefore, Gresham's. To many, cars were initially regarded as a nuisance. But soon their popularity and demand won out over horses. Dealerships developed, and among them was Fieldhouse Chevrolet, located on the southwest corner of Powell Boulevard and Hood Avenue.

Alfred Mealey owned a jewelry store located at 35 East Powell Boulevard in 1929. The store was certainly not as elaborate as modern jewelry stores, but a jeweler is located in proximity to this address even today.

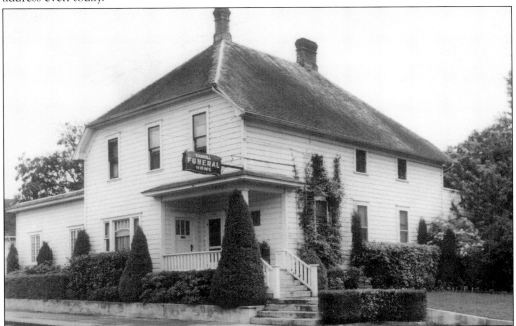

Edna and Charles Gates purchased the home of Boone and Hannah Johnson on South Roberts Road around 1916. Gates built a funeral chapel just north of the house. In 1930, William and Anna Carroll bought the business and later made improvements. The funeral home was consolidated with another (Bateman's), and the enterprise was moved to West Powell Boulevard. Today Gresham Memorial Chapel occupies the location.

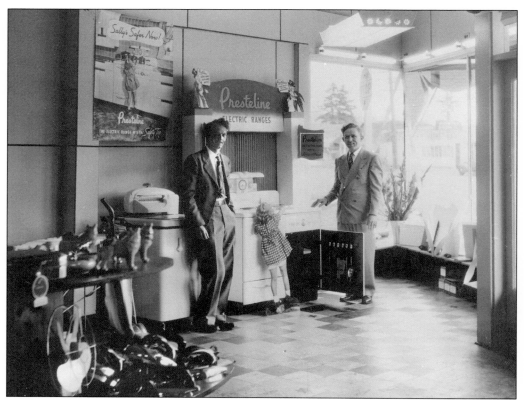

Appliance stores have been part of Gresham's business community for many years. The showrooms probably have not changed much, but appliances have. Both pictures are *c.* 1950. D. H. VanDeusen, more popularly known as "Van the Appliance Man," was at 53 East Powell Boulevard. He is shown below.

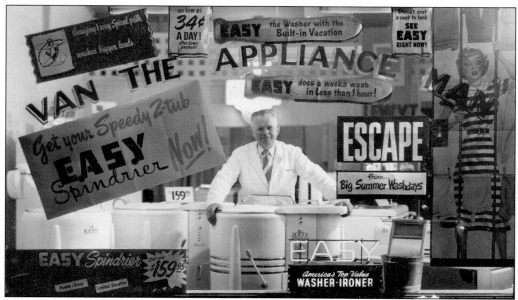

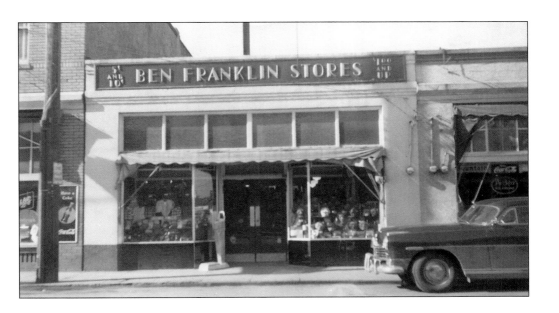

As is often the case today, many storefronts have two openings to two different businesses. The following buildings were all in the same section of Main Avenue and joined together. The building shown in the above photograph began as a harness shop around 1900. A map of Main Avenue from around 1930, as recalled by Dan Murphey in 1993, shows five businesses in this section of Main Avenue. One is a harness and leather shop. The Ben Franklin store opened in 1938, and later the Mode O' Day occupied one section of the street. Today the M&M Restaurant occupies the corner location, shown below.

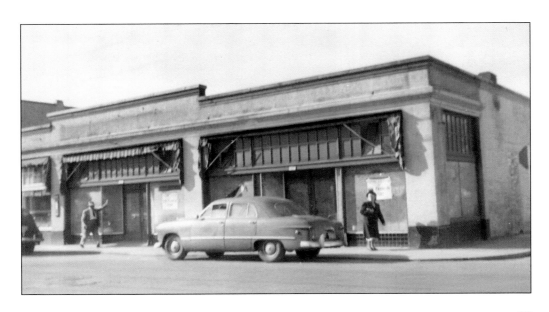

J. C. Penney came to Gresham around 1935 and is shown in various stages of construction in these photographs. It was located in the 300 block of North Main Avenue. Today it stands vacant.

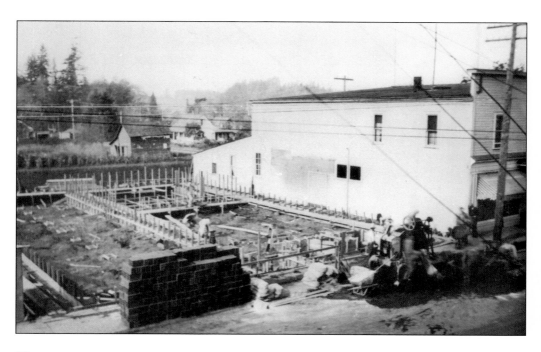

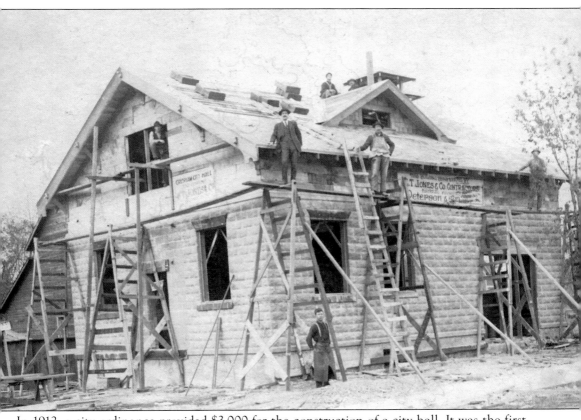

In 1912, a city ordinance provided $3,000 for the construction of a city hall. It was the first city hall in Gresham and was completed that same year at the corner of Roberts Avenue and Powell Boulevard.

Walter Quintin Gresham was appointed postmaster general in 1883 by Pres. Chester A. Arthur. He was a brigadier general in the Civil War and suffered a serious knee injury from a sharpshooter's bullet. He also served briefly as secretary of the treasury and was considered as a presidential candidate in 1884 and 1888 on the Republican ticket. The Gresham area had briefly been assigned a post office under the name Camp Ground. Benjamin J. Rollins is reported to have suggested the name Gresham because of the postmaster general, and when postal officials in Washington, D. C., recognized that the area had two names, Camp Ground was dropped, no doubt because of Gresham. (Photograph courtesy Library of Congress.)

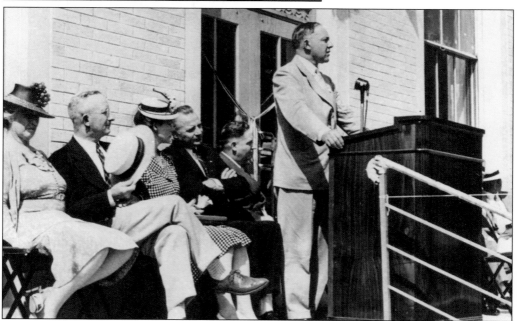

It was on June 9, 1911, that the *Gresham Outlook* reported, "One cent postage now a possibility." The new Gresham Post Office was dedicated at its current location on July 26, 1941. Present are, from left to right, Rep. Nan Wood Honeyman, state senator Lew Wallace, Mrs. Wallace, Gresham postmaster Ivan Swift, and chamber president Henry Rodgers. Gov. Charles A. Sprague delivered the dedication address.

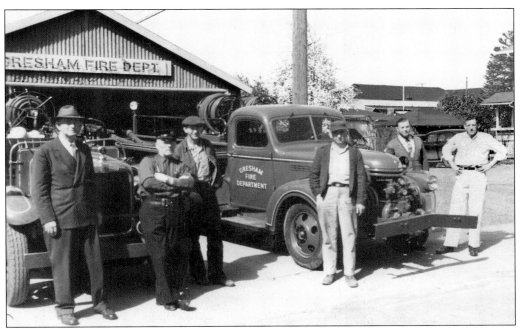

The disastrous fires that occurred in the early 1900s brought awareness of the need for a fire department. It began as a volunteer effort but was soon expanded, and professional services became a part of the city's services. Shown just outside their fire station behind the old city hall, on the corner of East Powell Boulevard and North Roberts around 1946, are members of the Gresham Fire Department.

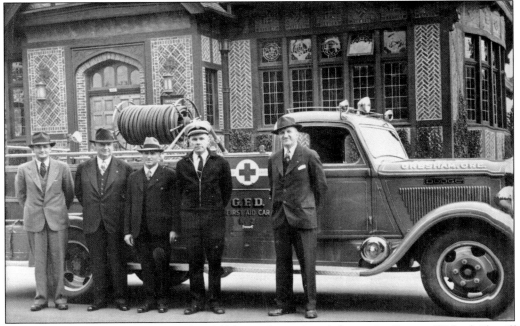

This photograph taken in front of the old library shows, from left to right, Burton Walrad, Sheriff Pratt, fire marshal Al Boslar, chief Harold Richmond, and Mayor Russell Akin.

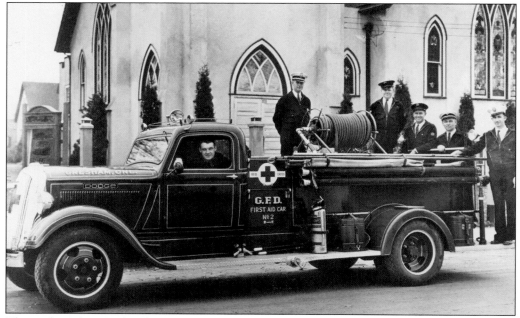

This is the volunteer fire department pictured in front of the Methodist church in 1940. Shown here are, from left to right, Glenn Ewalt (the driver), Al Camp, Clair Gullikson, Earl Jones, Icey Hjaltalin, and Staffard "Staff" Dowsett.

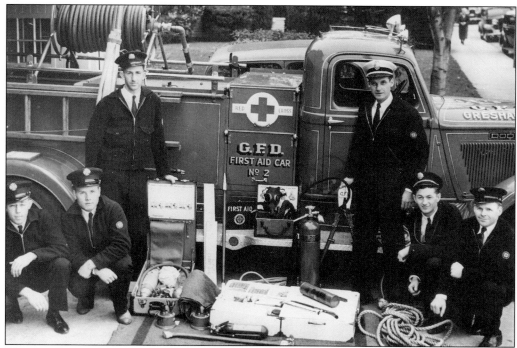

The Gresham Volunteer Fire Department First Aid Car is shown around 1940 with, from left to right, Verne Bjur, Vernon Rutherford, Staffard Dowsett, Capt. Glenn Ewalt, Chet Parker, and Clair Gullikson.

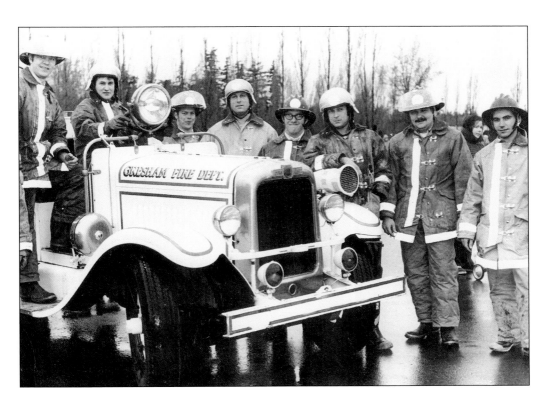

Firefighters are shown with "Old Betsy" around 1928 or 1929 (above). The only person identified is Tom Peterson, fourth from the left. In an even earlier photograph (below), individuals involved with the Red Cross during World War I are pictured.

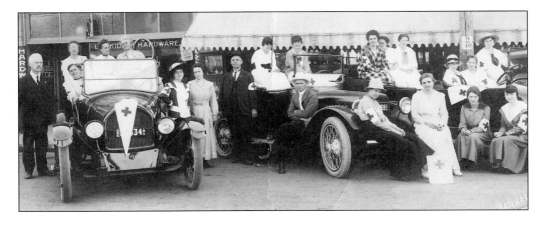

With only a few hundred people in the town in the early 1900s, it seemed as if a constable or marshal was all that was needed to enforce ordinances passed by the city. One of those ordinances was forbidding the tying of cows on the streets. Quickly, however, the need for a professional police force was recognized. By the late 1930s, the town had three policemen. Police cars were officially added to the city in the 1940s. Ron Bailey (at left) was chief of police in the 1950s. Dalton Eggleston (below, right) is shown at his desk with an unidentified partner in 1952.

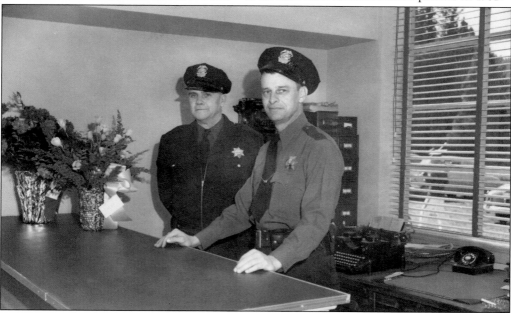

Seven

INDUSTRY

The Royal Horticultural Society of London sent botanist David Douglas to the Pacific Northwest in the 1820s. His mission was to identify plant life. Douglas firs, the tall, straight trees sometimes over 300 feet in height and common to the region, are named in his honor. Western red cedar was also a predominant part of the landscape at the time.

When the first settlers arrived, much of the land was covered by a dense growth of Douglas fir, western red cedar, and other species of trees. The forests had to be cleared for settlement, and in the few open areas, pioneers noticed the fertile land where almost anything could be grown that the climate would allow. Jackson Powell, one of the first settlers, reportedly searched the forests for open meadows where he could pursue his love of farming.

Early pioneers were mostly farmers. But soon after came lumbermen from the forests of the upper Midwest and East that had been mostly cleared by logging. They heard stories of the fabulous timberland in the Pacific Northwest, and they were not disappointed. Trees as much as 6 or even 7 feet in diameter were awesome and at first seemed to defy being cut. But springboards—boards inserted into the trunk of a very large tree on which a lumberman stood to hack or saw at the trunk—were inserted several feet above the ground in addition to long crosscut saws. The forests began to fall.

Several small sawmills sprang up in the area. The Metzger brothers started one of the first along Johnson Creek in the Cedarville area. Others were established along various creeks. But when the trees were cut, there was a problem of getting the huge logs to the mill.

Once the trees were cut and the stumps removed, the land was ready for agricultural production. Raspberries were introduced by H. E. Davis, the manager of a large farm owned by judge W. W. Cotton. It was just off Powell Valley Road. Soon after Davis's success, other farmers began planting the luscious crop. Strawberries and other berries followed. The Gresham area became a strong part of Oregon's agriculture.

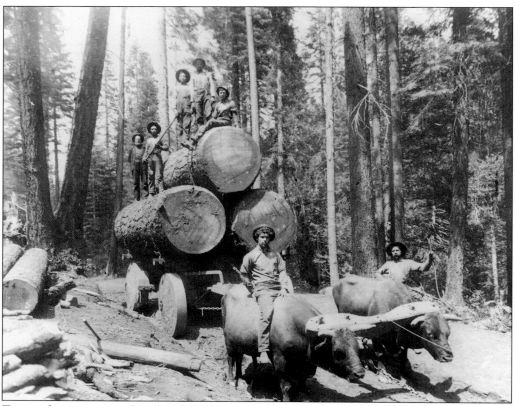

Teams of oxen were used in the 1800s to move the huge fir logs to the sawmill. The oxen would either pull a crude cart with the logs on it, or logs would be hauled out of the forest on a road made from skid planks or logs.

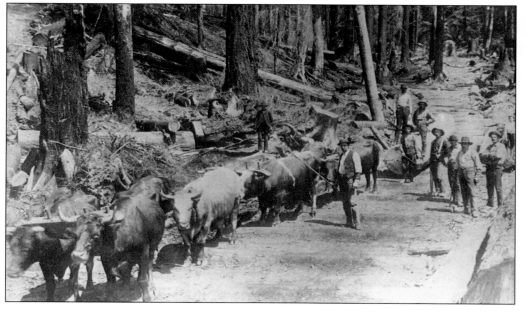

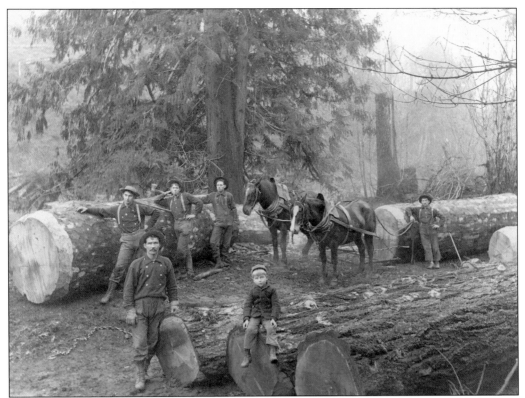

Teams of horses were also used extensively to bring the logs to the sawmill. In the photograph above, the ends of the logs have been tapered slightly to make pulling them easier for the horses. The logs were huge, and those timber cutters familiar with the much smaller pine forests in the East found that their implements were not suited for these massive timbers.

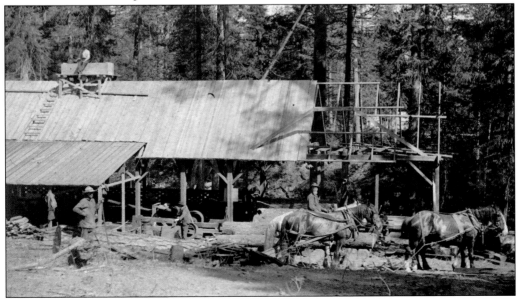

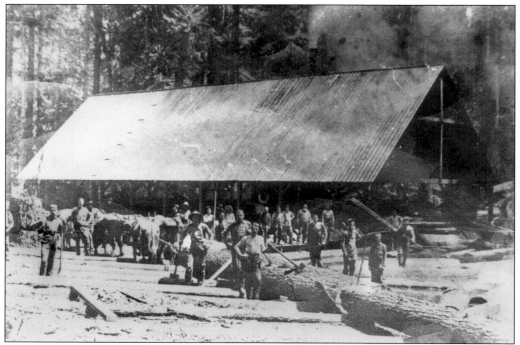

Once settlers and immigrant lumbermen realized the value of the Douglas fir and western red cedar forests surrounding Gresham and in the Pacific Northwest, small lumber mills were erected all over the area. One such facility was John Hillyard's, constructed in 1890, on Telford Road in proximity to Johnson Creek.

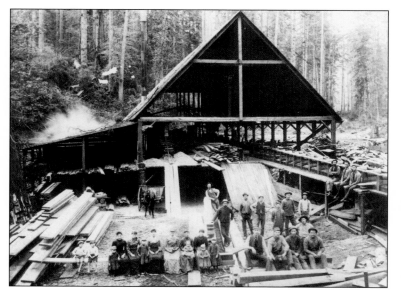

The Metzger Brothers purchased a sawmill that previously had three owners in the Gresham area. Although much of the timber harvested in the region was used in local construction, a large portion found its way south to California. Some of those pictured in this 1897 photograph are Frank and Annie Gibbs, John Henderman, and Jack Milde.

The use of "steam donkeys" to remove logs from the woods was a great improvement and gradually eliminated the need for oxen and horses for this task. Water was needed, however, to keep the steam engines running. There were occasions when the steam donkeys exploded because of a lack of water.

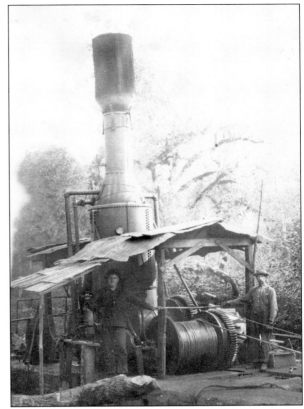

Bricks were also used in lieu of lumber in construction projects. Railcars were used to move the clay for bricks from pits in the area to storage sheds, such as these in the photograph.

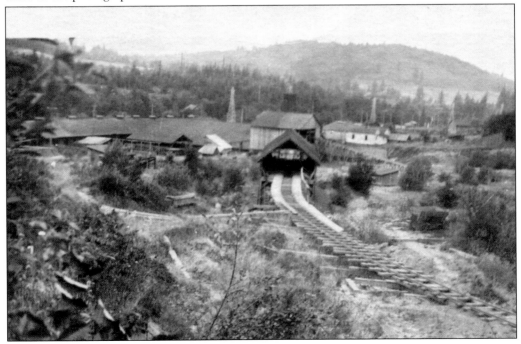

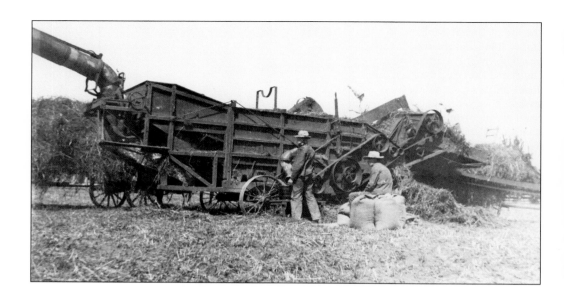

Early settlers soon learned how valuable and productive the ground was in Powell's Valley. Wheat was one of the prime crops since it grew very well in the rich soil. It was also a great commodity of the Pacific Northwest and was transported out of the Portland area on ships. Threshing machines in the early 1900s were powered by teams of horses. The machines would beat the wheat from the stalks of grain, after which it would be placed into baskets or sacks.

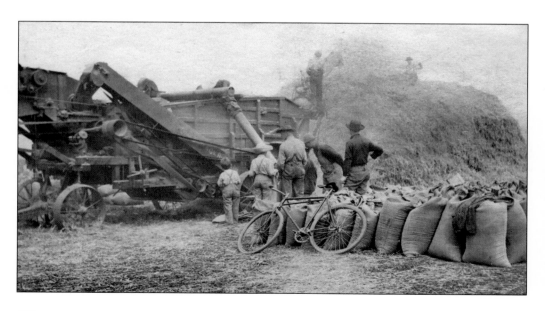

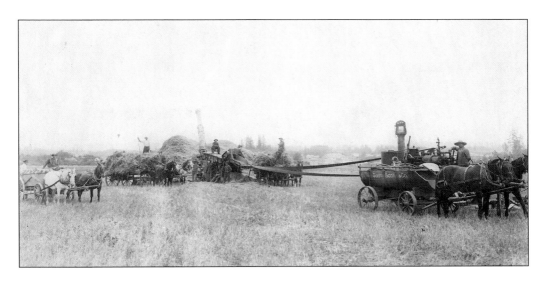

Later threshing machines were powered by steam engines that could be pulled into the fields. Belts from the engine then allowed the wheat to be separated from the chaff. Water was needed to power the steam engine, and the horses seen here are likely pulling a water wagon. Steam engines were usually separated from the threshing machines by some distance to eliminate the danger of fires from sparks. The chaff was bailed or used as bedding for stock.

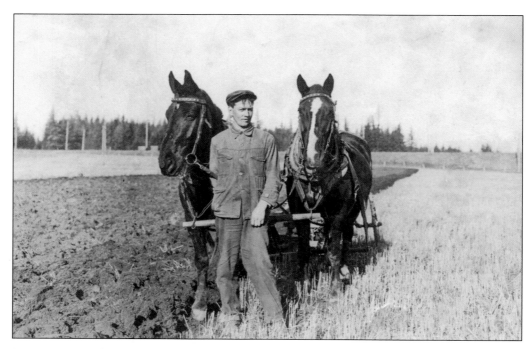

Horses were used to plow the ground in the fall when weather permitted and also in the spring prior to planting. The gentleman standing in front of the horse is William H. Stanley. The person at the end of the plow is Edward Aylsworth. Both pictures are from the 1920s.

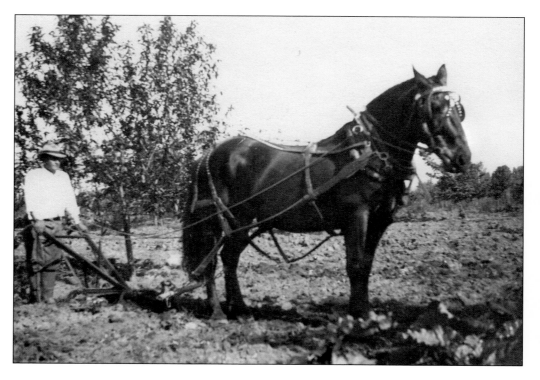

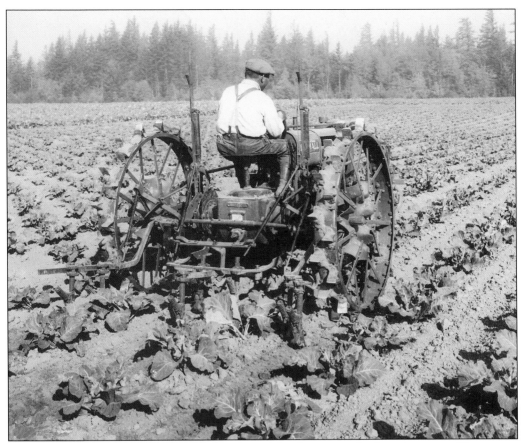

Tractors soon replaced horses in preparing the soil for planting and cultivating crops. The person on the tractor is likely Frank Tanaka, cultivating a field of cabbages.

Potatoes also grew very well in the area, and their abundance at one time allowed the making of starch. In addition to being dug by hand, potatoes were also harvested by a machine that was pulled by a team of horses, which removed the potatoes from the ground.

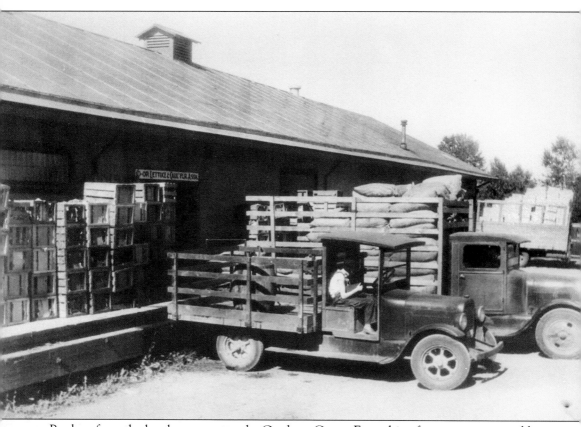

Produce from the local area went to the Gresham Co-op. Everything from potatoes, to cabbages, to lettuce, to berries, and even flowers would find its way, via trucks, to this central location.

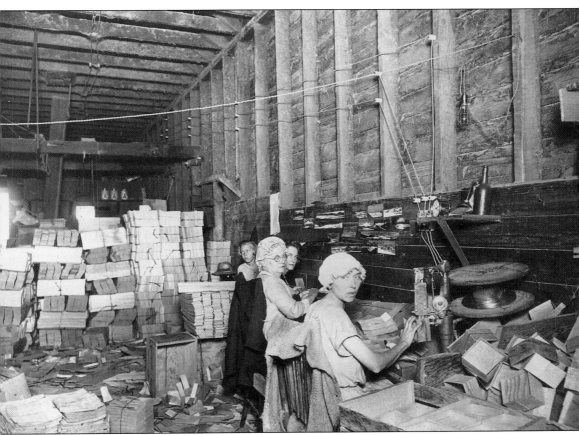

Boxes and crates were used to package the produce brought in from the fields. The Thayer Box Factory was located in the 100 block of East Powell Boulevard, in back of the Metzger Feed Store. Identified in this photograph are Robin Thayer (the little girl in the back) and Vera Thayer, her mother, at the stapler (right). The others are unidentified.

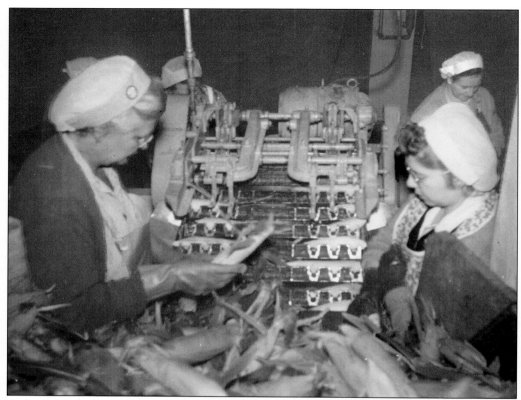

Early varieties of corn did not grow well locally. Later varieties, however, came to be a staple crop. The corn had the outer layers of husk and the silk removed before being fed into what was likely a steam machine. Later it was separated into groups of six for freezing or processing.

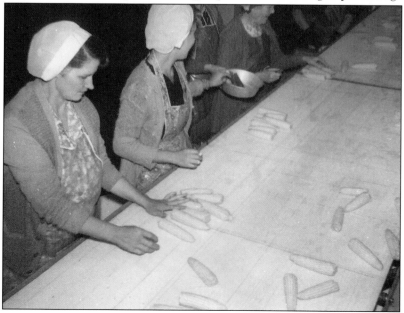

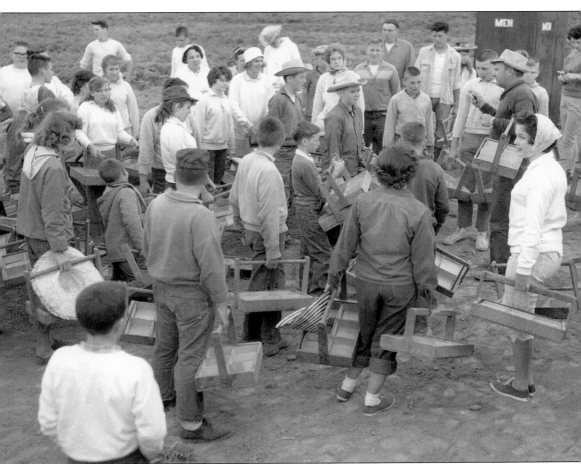

Strawberries became a lucrative crop in the area. Very few youth in the years prior to the 1970s went through the summer without a stint at picking strawberries in the numerous fields in the local area. Parents often accompanied their children into the fields. It appears the pickers have been assembled in this photograph to receive instructions. The crates were called hallock carriers.

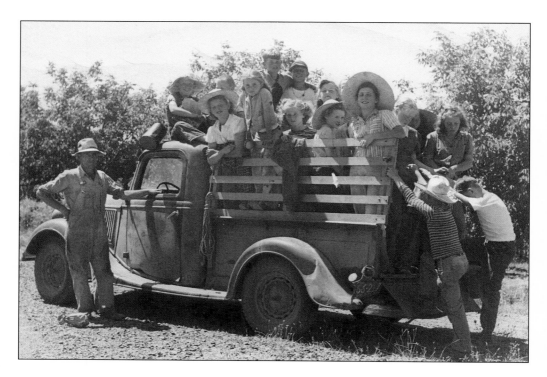

Buses and pickup trucks were used to transport the pickers to and from the fields. Initially there were no restrictions on young people working in the fields and certainly no restrictions on the number of people hauled in a truck.

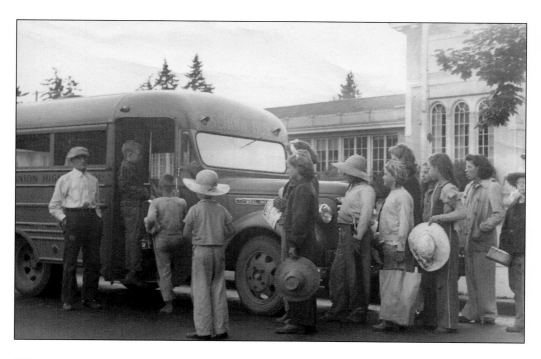

In favorable weather and with large, easily picked strawberries, an industrious picker could earn $5 or $6 a day. Carl Gotcher, age 12, made $17 over three days. The *Gresham Outlook* on May 30, 1911, issued a set of instructions to potential strawberry pickers: (1) Berries must not be picked while there is moisture on the vines; (2) Berries must be pink all over or three-fourths red; (3) Berries should be picked riper in cool weather than in warm; (4) Pickers must not be allowed to hold several berries in hand at the same time; (4) Filled carriers must not be allowed to stand in the sun; (5) Berries must be picked with stems a quarter of an inch long, not longer or shorter.

The Gresham area produced several types of berries and field crops such as beans, tomatoes, celery, and others. The produce being harvested below (raspberries?) remains a mystery.

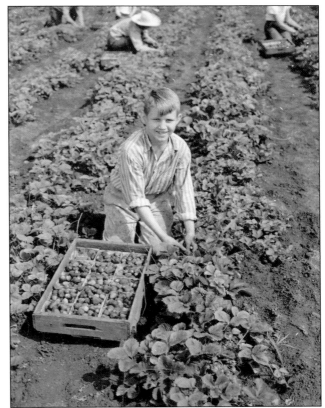

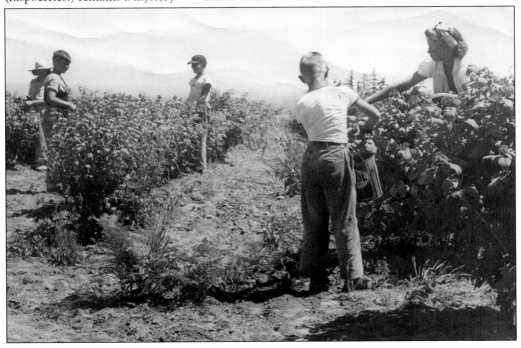

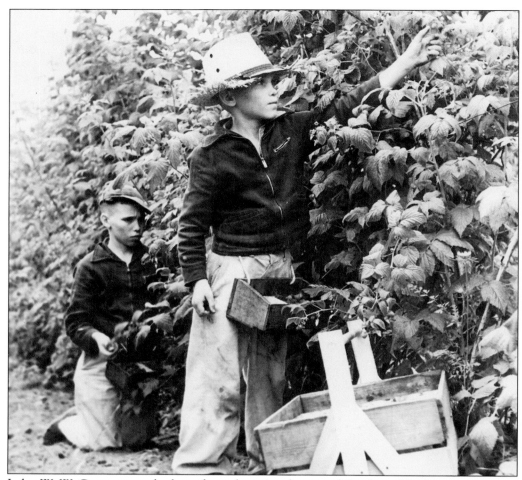

Judge W. W. Cotton owned a large farm about 1 mile west of Gresham. His farm manager, H. E. Davis, is credited with introducing raspberries to the local area in 1912. It was found that the crop was extremely bountiful and quite lucrative, and soon they were processed commercially. Once again, there were no age restrictions on who could pick the luscious fruit.

The correct way to pick raspberries, according to records, prescribed the picker hold the stem with one hand and gently pull the fruit away with the other. If it resisted, it was not ripe enough. Once vines were through producing, they were cut back. The new vines would then produce a crop next year.

Since raspberry plants grew upright, pickers did not have to kneel as they did with strawberries. This allowed use of a waist carrier in which to place fruit. Soon other farmers realized how beneficial raspberries were and there were many local growers. The Gresham Co-op was organized to oversee the raspberry crop and other produce as new crops were developed.

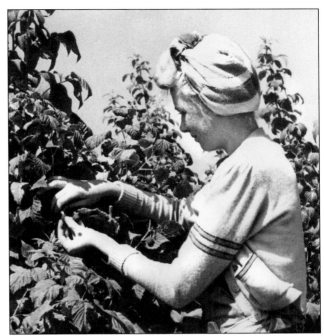

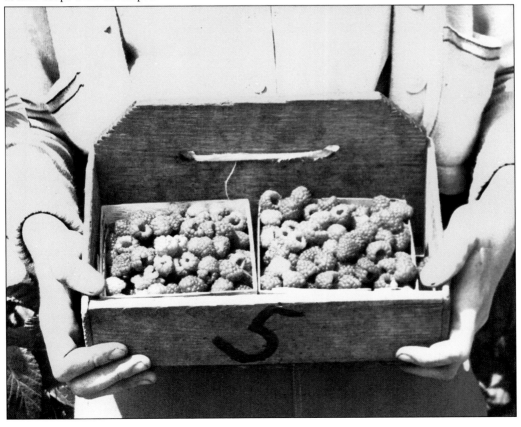

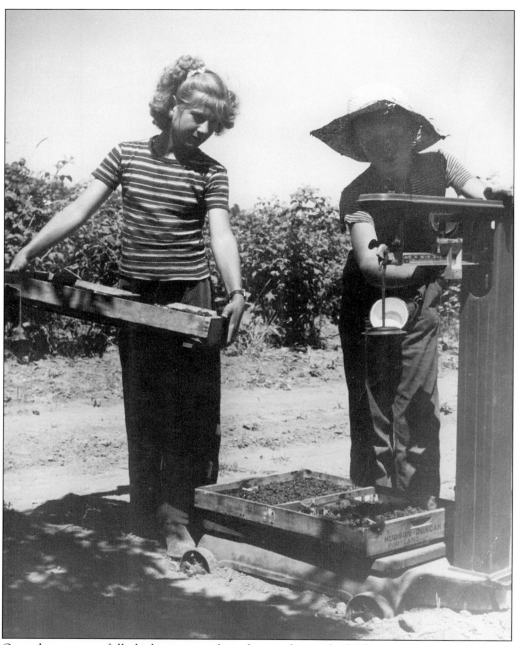

Once the crate was full, the berries were brought in to be weighed. The strawberry and raspberry seasons slightly overlapped, with strawberries ripening any time from the first of June well into July. Raspberries ripened slightly later and extended until the end of July. Eventually a raspberry festival was held in July, complete with a queen, parade, and floats.

June weather in the Pacific Northwest can present quite different faces. Some days were cloudy, drizzly, and cool; but on other days, the temperature in the fields reached into the 80s and even 90s on occasion. On those very warm days, pickers made frequent trips to the water cooler.

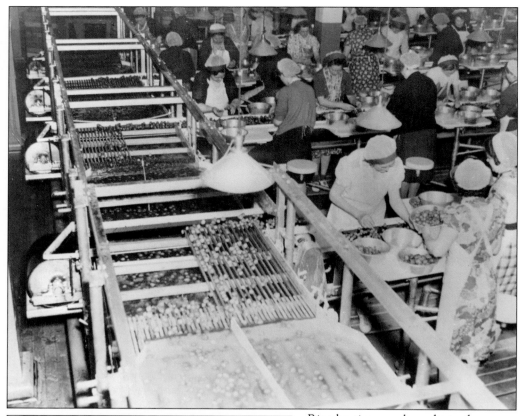

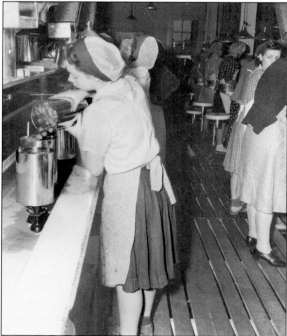

Ripe berries were brought to the Gresham Berry Growers plant where they were processed. Sorting was initially done by hand, but soon mechanical sorters were created to facilitate and hasten output. The plant was innovative and probably the first local one to begin packaging frozen fruit and shipping it throughout the nation.

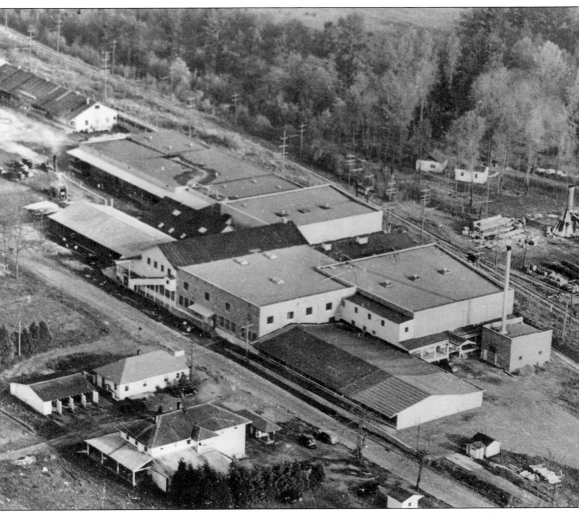

The Gresham Berry Growers soon developed a processing plant. It grew from a few buildings to several acres in the Gresham area. They were in existence for 45 years, eventually merging with the United Growers of Salem. This was later called the Stayton Canning Company, packing under the Flav-R-Pac label.

A group of the Gresham Berry Growers from the 1940s is shown in this photograph. They are, from left to right, C. E. Leof, Walter Johanson, H. J. Bushue, C. T. Ryan, James McBain, C. A. Becker, H. C. Compton, P. O. Pachard, and V. H. Supi.

BIBLIOGRAPHY

1899–1974, Trinity Lutheran Church. Gresham, OR: Trinity Lutheran Church, 1974.

A Pictorial History of East Multnomah County. Portland, OR: Pediment Publishing, 1998.

Archer, Howard. *Gresham, the Friendly City*. Gresham, OR: Gresham Historical Society, 1967.

A Century of Community, Gresham, Oregon, 1905–2005. A special publication of the *Gresham Outlook*, 2005.

Gresham Historical Society. *Gresham, Stories of Our Past, Book II: Before and After the World Wars*. Edited by W. R. Chilton. Gresham, OR: Davis and Fox Printing, Inc., 1996.

———. *Gresham, Stories of Our Past, Campground to City*, Edited by W. R. Chilton. Gresham, OR: Davis and Fox Printing, Inc., 1993.

Gresham Outlook, The. Various editions dating from 1911.

DISCOVER THOUSANDS OF LOCAL HISTORY BOOKS
FEATURING MILLIONS OF VINTAGE IMAGES

Arcadia Publishing, the leading local history publisher in the United States, is committed to making history accessible and meaningful through publishing books that celebrate and preserve the heritage of America's people and places.

Find more books like this at
www.arcadiapublishing.com

Search for your hometown history, your old stomping grounds, and even your favorite sports team.

Consistent with our mission to preserve history on a local level, this book was printed in South Carolina on American-made paper and manufactured entirely in the United States. Products carrying the accredited Forest Stewardship Council (FSC) label are printed on 100 percent FSC-certified paper.

MADE IN THE USA